# Contents

GW00469648

| | | |
|---|---|---|
| **Acknowledgements** | | 2 |
| **Foreword** | Janita Bagshawe, Director of the Royal Pavilion and Head of Museums, Brighton & Hove | 3 |
| **Introduction** | | 4 |
| Chapter 1 | **Breeched, Booted and Cropped** The Land Girls 1917-1919 | 6 |
| Chapter 2 | **The Battle for Food** The Land Girls 1939-1950 | 13 |
| Chapter 3 | **Uniform** | 25 |
| Chapter 4 | **Uniformity** | 41 |
| Chapter 5 | **A Biography of Breeches** | 45 |
| Chapter 6 | **21st Century Land Girls** | 54 |
| **Sources and selected bibliography** | | 61 |
| **Appendix** Agricultural statistics | | 62 |
| **Copyright credits** | | 64 |
| **Photographic credits** | | 64 |

# Acknowledgements

**Special thanks to:**

Dr Nicola Verdon, Senior Lecturer in History, University of Sussex, who provided specialist research on Sussex agriculture; London College of Fashion; land girl Doris Bradley; Clive Warwick and Doug Craib for photography.

**Thank you to:**

Brighton & Hove Museum staff, Jo Palache, Age Concern, Eastbourne, Julian Bell, Margot Bettles, Geraldine Biddle-Perry, Ruth Bowley, Judith Clark, Dr Gill Clarke, Dora Cronk, Rose Daniels, Brian Davies, Carly Eck, Eileen Eggleston, Diane Fisher, Ivy Goodall, Beryl Gould, Daniela Hatfield, Iris Hobby, Jeff Horsley, Geraldine Howell, Imperial War Museum, especially Matthew Lee and Kate Donnington, Pat Jobsey, Nancy Johnson, Eileen Jones, Junk TV Ltd, Shonagh Marshall, Stella Masters, Dorothy Medhurst, Valerie D. Mendes, Dr Catherine Moriarty, Matilda O'Flynn, Alice Racher, John Randle, Kath Roberts, Peggy Sayers, Lindsey Smith, Eileen Strong, Professor Lou Taylor, Professor Helen Thomas, Wendy Toomer-Harlow, Carol Tulloch, Dr Ida Webb, Professor Elizabeth Wilson, Una Wilson, Di Winstanley, teachers and pupils from Cardinal Newman Catholic School, Brighton, especially Kate Forbes, Sebastian Philips, Emma Taylor and the Year 8 pupils (2008-09) Aidan, Beatrice, Becky, Chloe, Eleanor, Grace, Hannah, Holly, Leslie, Lizzie, Lottie, Phoebe and Serena.

**For generously lending to the exhibition we thank:**

Cuckfield Museum, Ditchling Museum Trust, East Sussex Record Office, Government Art Collection, Harris Museum and Art Gallery, Hastings Museum and Art Gallery, Imperial War Museum, London, Manchester City Galleries, Newhaven Fort, Evelyn and Geoff Paine, Portsmouth Museum and Records Service, Russell-Cotes Art Gallery and Museum, Seaford Museum and Heritage Society, Steyning Museum, Tate, London, University of Brighton, Worthing Museum & Art Gallery and the many private collections.

**We are particularly grateful to the following for their generous support:**

BBC Sussex, Brighton & Hove City Council, Heritage Lottery Fund, Lloyd Loom Furniture, Renaissance South East, Their Past Your Future Phase 2 Programme and University of the Arts London, London College of Fashion.

# Foreword

The Royal Pavilion & Museums, Brighton & Hove are delighted to have the opportunity to tell the story of the forgotten army of the land girls. During World War II over 200,000 women joined the Women's Land Army. The heroic image of the land girl standing tall in her striking corduroy breeches, green jumper and brown felt hat, fork resting over her shoulder, has become an iconic symbol of the triumph of wartime agriculture.

It is especially appropriate that *The Land Girls* is taking place here in Sussex. The Headquarters of the Women's Land Army were at Balcombe Place in Sussex; land girls were trained at Plumpton Agricultural College, and lived and worked on the Sussex Downs and surrounding areas.

The land girls have had a long wait for recognition of their crucial contribution to the war effort. When the Women's Land Army was disbanded in 1950 they received neither medals nor gratuities. It was not until 2008 that they were finally given official recognition from the British Government with the award of a commemorative badge in honour of their service.

A project such as this cannot be achieved without the valued contribution of many individuals and organisations; we are very grateful to them all and thank them for their wholehearted support. We give special thanks to Amy de la Haye, whose long-time interest in the land girls has been the driving force behind this exhibition. Most importantly we are enormously grateful to the many land girls who have supported this venture in so many ways, sharing their memories, photographs, memorabilia, collections and their time. Without them *The Land Girls: Cinderellas of the Soil* could not have taken place – thank you all.

*Janita Bagshawe, Director of the Royal Pavilion and Head of Museums, Brighton & Hove*

# Introduction

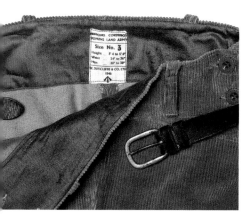

**I Detail of a pair of WLA breeches, 1946**

*Cotton corduroy, manufactured by W. Sutcliffe & Co Ltd*

During World War II (1939-1945), women's land armies were established in America, Canada, New Zealand, Australia and Britain. Their primary role was to ensure the continued production of essential foodstuffs when farmers were redeployed into the armed services. The role of the land girls (as they were known and as they still describe themselves) as part of Britain's Women's Land Army (WLA) changed them both experientially and physically. Friendships were forged, and are today made, on the basis of their shared rewards and challenges. The distinctive breeched uniform the land girls wore formed part of their daily lives, shaped their identities and influenced broader perceptions of them.

This book, and the exhibition it accompanies, focuses upon the WLA in World War II and the Sussex experience in particular. There is a brief examination of the land army that was formed in 1917, during World War I (1914-1918) to provide context. The narrative is woven around the uniform worn by the land girls.

During World War II the WLA was documented contemporaneously, in official publications such as *Land Girl: A Manual for Volunteers in the Women's Land Army* (1939); *The Women's Land Army* by Vita Sackville-West (1944); and the monthly journal *The Land Girl*. In both world wars, local and national government bodies commissioned documentary photographs and artworks, and these sources provide a wealth of diverse imagery that relates to women, uniform and the WLA. Film recorded the land girls in action: newsreels document them marching in rallies and working on the land, whilst the fictional narrative 'A Canterbury Tale', released in 1944, starred real-life land girl and actress Sheila Sim. Just after the war, several women published accounts of their personal experiences: evocative and romantic titles include *If Their Mothers Only Knew!* (1946) and *Fragrant Earth* (1947). The delightful wood engravings and sensitive wartime diary of Sussex-based Gwenda Morgan was published posthumously in 2002.

Most fortunately, a number of WLA's documents, including the extensive correspondence of Lady Denman to various government bodies as well as internal documents have been preserved by her family. In 1939 she was appointed Honorary Director of the Women's Land Army for England and Wales. Lady Denman's daughter, Judith, Lady Burrell, served as WLA County Representative for West Sussex and sat on the WLA Committee of Management. WLA documents are also housed at the Public Record Office. In addition there survives an abundance of visual evidence, including official and personal photographs and paintings, located in private collections, regional and national museums.

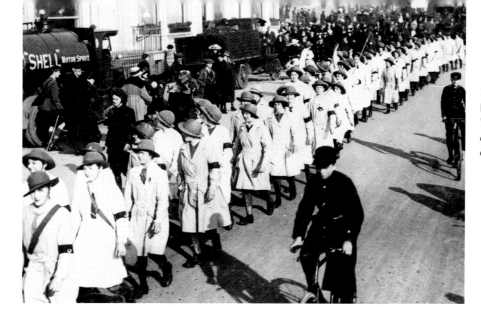

Since the early 1980s, a number of land girls have recorded (by the spoken and written word) their wartime memories. Some have been facilitated and supplemented by the work of historians, curators and publishers working within various disciplines, including women's studies, agriculture/farming, wartime studies (notably those about the home front and women's war work), local and oral history. For this project staff from the Royal Pavilion & Museums, Brighton & Hove conducted a number of the interviews referenced here, which are now held in their collection.

A new generation was introduced to life in the WLA by the popular novel *The Land Girls* by Angela Huth (1994), which was made into a film directed by David Leland (1998). Most recently, the historical document has been greatly enriched by Dr Gill Clarke's rigorous biography of the painter Evelyn Dunbar (*Evelyn Dunbar;War and Country*, 2007) and the exhibition at St. Barbe Museum & Art Gallery, Lymington of paintings by various artists with an accompanying book *The Women's Land Army: A Portrait* (2008).

In a departure from previous research, this project explores surviving garments that formed part of the WLA uniform, to unravel stories about lives lived not only in the 1940s but also in the 21st century. Today the land girls, now in their 70s and 80s, bear witness to a new era of austerity: a time of grave concerns about man's impact upon man, the food we eat and the global environment. In 2009, as in 1939, Britain imports over 50% of its foodstuffs. On 29 March 2009, almost 70 years after the declaration of war, *The Sunday Times* ran an article about the increased demand for allotments, prompted by climate change and the credit crunch rather than German U boats, called 'Trowels out everyone and dig for victory'. Meanwhile, the living history movement and wartime re-enactors seek out and wear original WLA uniform. The parallels between then and now are poignant.

# Breeched, Booted and Cropped
## The Women's Land Army 1917-1919

*'Breeched, booted and cropped, she broke with startling effect upon the sleepy traditions of the English countryside.' David Lloyd George, British Prime Minister 1917–22*

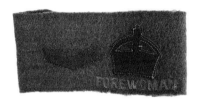

**3 World War I Forewoman armlet c1917**
*Felt*

The Women's Land Army was established in February 1917, two and a half years into the war and at the point when food shortages had become critical: it was estimated that supplies could last no more than three weeks.[1] The dashing land girl evoked by Lloyd George presents her as dislocated: in her uniformed persona she was emblematic of an implicitly urban modernity.

When war was declared in 1914, some 50% of food consumed by this island nation was imported. Since the late 19th century the countryside had been steadily depopulated, and land left fallow, as agricultural workers were lured away by higher wages and new opportunities offered in the towns and cities. In 1914 there was an exodus of a further 250,000 fit men: Lloyd George recalled how '… the military representatives cast covetous eyes on these sturdy sons of the soil, and took every opportunity to slip them into khaki.'[2]

In 1915 the Board of Agriculture formed the Women's National Land Service Corps with the objective of training 2,000 'educated women workers' to recruit an additional 40,000 'village women' to work on the land. The year 1916 witnessed the first of a series of poor harvests, which were accompanied by a sharp rise in the price of imported foodstuffs as the threat of enemy U-boat action became omnipresent. On 29 February 1916, Viscountess Wolseley had a letter published in *The Times*. It was titled 'Women and the Land – An Urgent Call' and appealed to 'educated women to enroll for work'. (She had formerly worked as Vice President, to Lady Chichester, of the East Sussex Women's Agricultural Committee and had written two well-received books, *In a College Garden* and *Women and the Land*, both published in 1916.) Although the Land Corps was a national organisation and actively appealed to the patriotism of recruits and farmers, its proposals were often dismissed and their representatives derided as the 'lilac sunbonnet brigade'.[3] In turn, the Land Corps, issued with only a badge and a baize armlet to an-

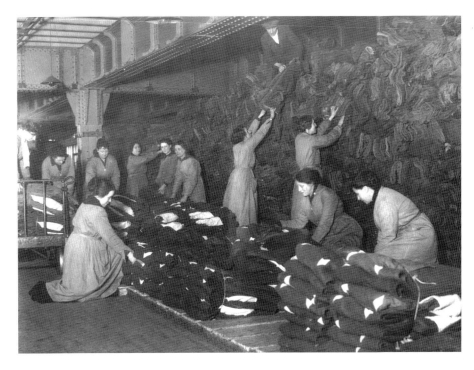

nounce their allegiance, were to report that they did not feel like 'real' war workers.

With the appointment, in December 1916, of Roland Prothero as Director of the Board of Agriculture, an organised food policy was instituted. This included the Corn Act of 1917, which saw the introduction of a guaranteed minimum wage to retain agricultural workers; granted the Board ultimate authority over land and created a separate Women's Branch. The latter was headed by Miss (later Dame) Meriel L Talbot (1866–1956), who was already engaged in government work and had been active in the introduction, in 1915, of the Federation of Women's Institutes (based on the Canadian model).

In 1917 a further 30,000 agricultural workers were called to the colours. The new workforce of women, prisoners and prisoners of war, and the implementation of more labour-saving mechanical appliances (formerly regarded as too costly and treated with suspicion by much of the farming community) had become of vital importance.

Miss Talbot had already divided the women labourers into two groups: those who could undertake casual or part-time work but could not leave their homes, and those who could provide full-time service and could go wherever they were sent. It was from this latter group that the strategically named Women's Land Army was formed, with Miss Talbot as Director and the Hon Mrs Alfred Lyttelton, GBE, as her deputy.

## 5 Women's Agricultural Section c1918

*This portrait, by Horace W Nicholls, forms part of a photographic commission he received from the Department of Industry and the Imperial War Museum to document uniformed women during wartime. The light coloured overall features a broad, protective, shawl-like collar which, along with the laced neckline is characteristic of rural women's dress dating back to the 15th century.*

## 6 Uniformed member of Forage Section of Land Army c1918

*'How thankfully we discarded our make-shifts and dived in to the white overalls and stepped into the breeches, and fastened on the leggings! Even if the fit was not exactly tailor-made they seemed to give out a peculiar odour of utility and comfort.' The Landswoman[7]*

## 7 Timber Supply Dept. of Land Army c1918

*A member of the Timber Corps wearing uniform distinguished by an embroidered badge (sewn onto the upper left arm of the overall coat) that depicted a tree. She wears the beret that became so distinctive of this Corps.*

## 8 Land Army Section Leader c1918

*The shift from a smock to an overall was significant in reframing farming as a modern industry (whilst simultaneously extolling the traditional virtues of the land). On her lapel the Section Leader wears a circular badge, which is emblematic of her elevated status.*
Photographs by Horace W Nicholls

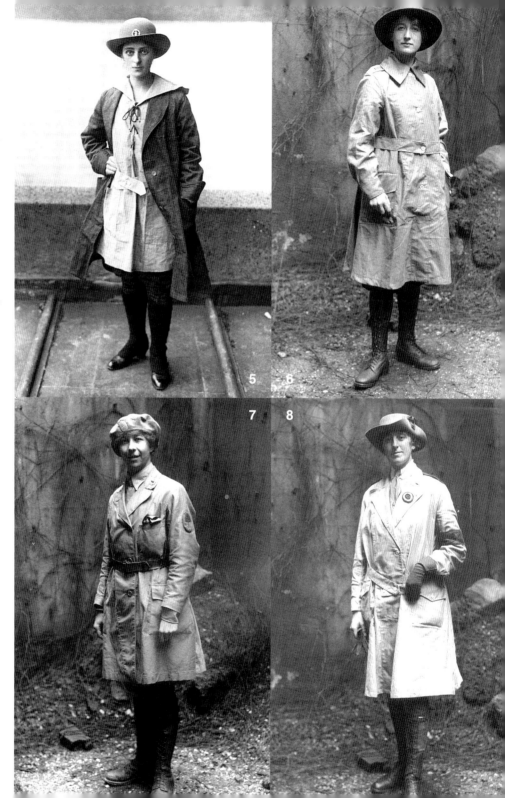

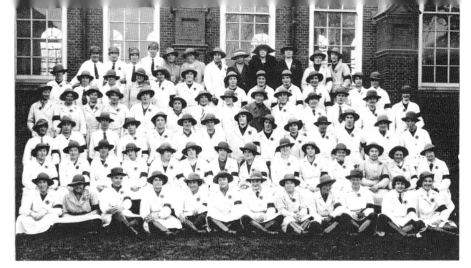

**9 Newly qualified land girls 1917–19**
*New recruits were enrolled on a free, month-long, residential agricultural course at one of the 600 training centres established throughout England and Wales. Seen together as a regimented 'body', the uniform worn by the land girls signifies their conformity.*

'Come out of the towns
And on to the Downs
  Where a girl gets brown and strong,
With swinging pace
And morning face
  She does her work to a song.'
(from the Land Army song, *L.A.A.S. Handbook*, 1917: 1)

The competition for women's wartime labour was steep. Thus, WLA propaganda deftly extolled the restorative and redemptive qualities of the land (to the women) as well as a woman's seemingly natural capacity to nurture (as opposed to destroy).

The Ministry of National Service assisted with the initial recruitment for the Women's Land Army and the Army Clothing Department co-ordinated uniform supplies.

Uniform was to assume an important role. A contributor to the monthly journal *The Landswoman* was later to recall, in April 1920 'So pressing had become the problem of dress that these tattered plough-girls could see little beyond the promise of free outfits! Their brows cleared, a new light shone in their eyes. That sense of depression that shabby clothes brings began to vanish. Better days were in store for them. The Land Army had come!' As *The Landswoman* observed, 'Until they did it in uniform it was not noticed.'[4]

New recruits were rigorously selected: of an initial 47,000 applications, just 7,000 were accepted;[5] many were simply not fit enough, but WLA organisers were also unashamedly selective in favour of 'educated women'. Viscountess Wolseley was appointed Organising Secretary for East Sussex. The first land girls were enrolled in March 1917; their starting wage was guaranteed at 20s a week, rising to 22s once they passed the proficiency test. Recruits could serve in Agriculture, Timber or Forage (animal feed-stuffs).

Each land girl was issued with a head-to-toe uniform comprising two pairs of boots, two pairs of gaiters, one pair of clogs, three overalls, two pairs of breeches, two hats, a

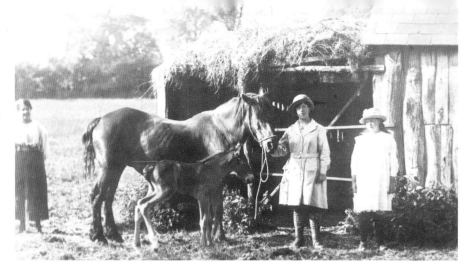

**10 Postcard 1917–19**

*As the land girls were dispersed across the length and breadth of the country, they were often seen (and photographed) with other agricultural workers. In these situations their uniforms looked relatively distinctive.*

jersey and a mackintosh. Whilst the land girls were not subject to military discipline (it would not have been feasible, as they were scattered across the country), they were reminded how important their behaviour was to the 'uniform', even when they were not wearing it. *The Women's Land Army L.A.A.S. Handbook*, 1917 (LAAS stands for Land Army Agricultural Service) informed them that they must avoid entering the bar of a public house, must not smoke in public, were not to be out too late at night and that they should attend public worship.'[6]

The *L.A.A.S. Handbook* sternly reminded their breeched recruits that 'You are doing a man's work and so you are dressed rather like a man; but remember that just because you wear a smock and breeches you should take care to behave like an English girl who expects chivalry and respect from everyone she meets. Noisy or ugly behaviour brings discredit, not only upon yourself, but upon the uniform, and the whole Women's Land Army.' [8]

Whilst women from different walks of life were often mucking in together, social distinctions were not – even temporarily – subsumed. The editorial of *The Landswoman* conveyed the elitist social attitudes and broader cultural views held by WLA organizers. One article, 'Our Cows' (March 1919), used anthropomorphic examples to stress that even on the land the 'natural' order of social distinction prevailed: 'Our cows are ladies of both high and low degree. Wayward, gentle, hot tempered, submissive, homely, and beautiful, they are like every other mixed community of females.' Whilst Polly was 'rude and rough and greedy', Lady Betty was '…quite above the status of the ordinary cow, both as regards birth, education, intellect, and social standing, and she wishes you to understand as much.' This was made all the more apparent by the bespoke ensembles some had purchased. *The Landswoman* reported that, whilst standard issue uniform was welcomed by the majority of land girls, 'The wealthy ones had visited Selfridges, and these had done the thing in style: silk skirts, smart corduroy breeches, brown leather leggings, elegant boots, sou'westers for wet days, the latest thing in service gloves.' [9]

The land girls, like those serving in the armed forces, were eligible for awards of merit. The Good Service Ribbon was given to each member who had completed at least six months' service and had no complaint brought against them – either on or off duty. Some 8,000 of these were awarded. Of higher value was the Distinguished Service Bar (also known as the 'Victoria Cross of the Land'), which was bestowed upon those who had taken life-saving action, such as that demonstrated by Miss L M Fisher from East Sussex, who was commended 'For great courage and presence of mind shown in saving a fellow-worker when attacked by a bull.' [10]

**11 Vera Butler (left) and Cathy Evans, Upper Wyckham Cottage, Steyning, West Sussex, c1917**

*The 'dark', constructed ambience and domestic context of this photograph are unusual and contrast sharply with Government propaganda images of bonny land girls taken amidst idyllic landscapes with picturesque rural 'props'. Vera left the farm in favour of working in an aeroplane factory in nearby Brighton.*

Whilst British farming remained labour rather than capital intensive, there was a gradual investment in tractors, potato diggers and other mechanical aids. Between 1917 and 1918 there was an increase of 822,000 tons of wheat and 619,000 tons of potatoes grown. In addition, more and more families started to grow their own food: in 1918 there were more than 800,000 allotment gardens than before the war, each producing about a ton of food each. [11] By February 1919 the Women's Land Army had supplied some 16,000 women for farm and field work, not including those engaged within the Timber and Forage Corps (which came under the control of the Army Service Corps and the War Office, as opposed to the Board of Agriculture). Combined, recruits numbered some 23,000. The WLA was demobilised on 30 November 1919. In its 27 December 1919 issue, *The Queen* ladies' paper marked 'The Passing of Britain's Land Army', and noted 'The English country-side will certainly miss the picturesque figure of the land girl in her dust-coloured breeches, her white overall, and wide-brimmed hat.'

Rather like the cycle of the seasons and rotation of crops, the countryside was considered to have revitalised the land girl who in turn had restored its land. But the imagery evoked by the fertility of the soil, and of growth and regeneration, could not have been further removed from the trenches where so many lives were taken.

**12 Lady Denman's photograph album, 1914–23**

*Lady Gertrude 'Trudie' Denman was appointed Director of the Women's Institutes' branch of the Food Production Department in 1917. She served as Chairman of the Women's Institutes from 1917 until 1946.*

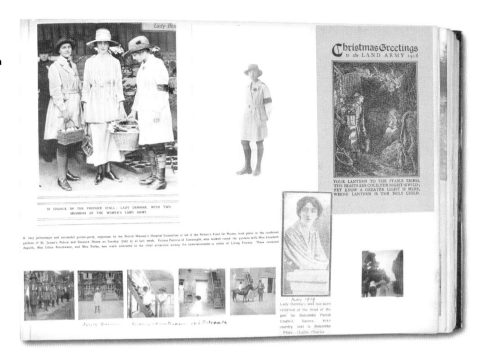

**13 'The Landswoman: The Journal of the Land Army and the Women's Institutes'**

*The monthly journal was printed from January 1918. In both world wars, drawing on Lady Denman's affiliation, the land army had close links with the Women's Institute.*

1. Talbot, Dame Meriel, in *Land Girl* by W.E. Shewell-Cooper, English Universities Press Ltd, London: 8
2. Lloyd George, David, *War Memories of David Lloyd George*, Odhams Press, reprint 1938: 770
3. Lloyd George: 772
4. 'Concerning our Uniform', *The Landswoman*, November 1918: 240
5. Lloyd George: 773
6. *The Landswoman*, February 1918: 733
7. *The Landswoman*
8. *Women's Land Army L.A.A.S. Handbook* 1917: 6
9. 'Clothes', *The Landswoman*, April 1920: 74
10. *The Landswoman*, October 1919: 244
11. All agricultural statistics, Lloyd George: 772–82

# The Battle for Food

## The Land Girls 1939-1950

'Back to the Land, we must all lend a hand,
To the farms and the fields we must go.
There's a job to be done,
Though we can't fire a gun
We can still do our bit with the hoe.'

(First lines from the Land Army song, 'Back to the Land' by WLA volunteers
P Adkins and J Moncrieff, with music by E K Loring)

By 1939, Britain was importing 60% of its foodstuffs – 10% more than in 1914. During the 1920s and 30s the farming community had responded to increased demands for eggs, milk, 'choice' fruit and vegetables – items formerly considered luxuries. Cereals and grains became less profitable, once-fertile land lay fallow and low-cost produce was imported from America. At the height of the Depression, the Government introduced legislation to support farmers and ensure basic foodstuffs: tariffs were imposed on soft fruit and potatoes in 1931, and the Wheat Act of 1932 restored the principles of the 1917 Corn Act. (Guaranteed prices for wheat and oats had been withdrawn in 1921 and the Act repealed in 1922.) In addition, milk and potato marketing boards were established in 1933 to regulate these nutritious foods. From 1937, following the introduction of the Agricultural Act, grants were provided for land drainage and fertilisers. The message was unequivocal: the Government was preparing the land to increase food production in case of war. As part of this process, a Women's Land Army was organised and ready to start work when war was declared on 3 September 1939.

Lady Denman, DBE, was appointed Honorary Director of the WLA for England and Wales. In Scotland and Northern Ireland separate agricultural departments were created to co-ordinate the work of land girls. From 1939 to 1944 Lady Denman made her Sussex home, Balcombe Place in Haywards Heath, available to the WLA for their headquarters. Each county had its own committee and chairman: in East Sussex Countess de la Warr performed this role (to be replaced by Mrs Brooke in 1945). In West Sussex it was the Hon Mrs Burrell.

**14 Photograph album presented to Lady Denman by her staff, Christmas 1942**

*This green leather-bound photograph album, with incised lettering and an impressed WLA badge on the cover, includes these photographs taken on the Sussex Downs. The original caption for the official photograph top right, taken in August 1941, reads 'Former typists and shop girls are helping to cut one of the two largest wheat fields in Britain, each of 400 acres, on the Sussex Downs. The fields are part of 5,000 acres of once-derelict ground which will produce £85,000 of food this harvest.'*

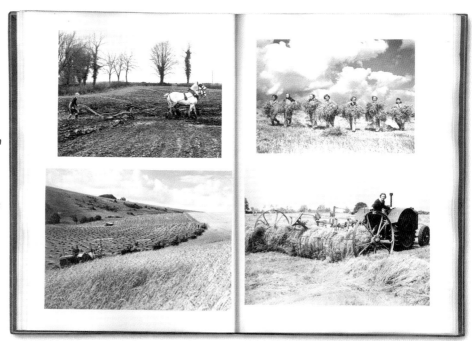

A recruitment campaign encouraged women to apply to serve in the WLA, 'For a happy, healthy life'. In January 1940, *Picture Post* reported that most recruits for the WLA came from the towns. 'Of a typical batch of one hundred and eighty girls sent to a training centre, only one was a farmer's daughter. The rest – thirty-eight peace-time occupations between them – included librarians, short-hand typists, chauffeuses, dress-makers, actresses, hairdressers, governesses, an artist, a poetess, and one who registered herself as a "television girl". Their ages ranged from eighteen to fifty-three; their social standing covered the ground from domestic servant to domestic ornament (with independent means).' The WLA's approach to cultural diversity was, not uncommonly for the time, less inclusive. An 'Organisational Leaflet' advised county representatives that whilst '…regulations permit acceptance of aliens for enrolment (including women refugees) … it is generally difficult to place aliens, since many farmers are unwilling to employ volunteers who are not British born and of British nationality, and in any case any available British women must be given preferences.'

Before the war Eileen Jones had worked in a factory; she joined the WLA because she was '…desperate to get out in the fresh air.' M Bettles recalls her husbands concerns: 'Well … he didn't want me to join the forces, but the Land Army didn't need permission from my husband in those days, so I was free to join. He couldn't stop me! The

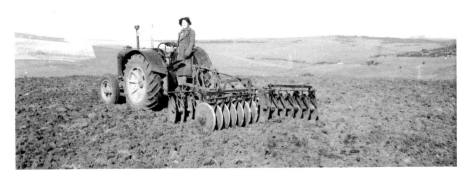

Land Army work interested me...' She had worked as a trainee window dresser beforehand. For Dorothy Medhurst, it was '...The fact that I didn't want to go into any of the services. I couldn't bear the thought of saluting people or calling them "Ma'am", you know, drilling and all that. I didn't want to go into a factory in the North, so I saw this poster for the Land Army - and that uniform, and the girl just waving bits of straw attracted me. So that was it.'

The land girls soon realised the job involved arduous and often unpleasant work – including rat-catching, ditching, hedging and muck-spreading. They had to rise before

**17 Official photograph from the series 'They learn to be Lumberjills', 1943**

*Land girls use a double saw to cut down a tree as part of their month-long forestry training at a camp in Culford, Suffolk. By 1943 Britain was importing only 25% of the timber it needed, compared to 90% pre-war.* [4]

dawn and work in all weathers, 48 hours a week (or more), for 28s (increasing to 48s in 1945). Each land girl was issued with a distinctive breeched uniform similar to that worn in World War I. (The uniforms are examined in depth in subsequent chapters.) Some volunteers were given training either on a farm (the Government paid farmers 15s a week for four weeks to train a girl and provide board and lodging), or at a farm institute or agricultural college.

Land girl Dorothy Medhurst joined the WLA and worked as part of a gang of labourers in Peacehaven and Lewes. She had to drive a tractor, but received no formal training… 'Just the farmer's son, who showed me what to do, you know. It was one of those old Fordson tractors, not like the modern nice ones, and he just showed me what to do. "You push this and you push that, and you do this". So you had to learn that quickly.'

Between 1939 and 1941, 50,000 agricultural workers were recruited into the armed forces. And the nation as a whole – from schoolchildren to soldiers home on leave – were urged to 'Join the Victory Harvest' and 'Dig for Victory'. By 1944 there were 500,000 more allotment holders than in 1939. [2] In December 1941 *The Land Girl* reported that there were 20,800 employed land girls, 771 working in East Sussex and 489 in West Sussex. By 1942, 70% of food was home-produced, and there were bumper harvests in both 1943 and 1944. Milk was also of prime importance. During World War I, milk production had fallen by 40%, but in World War II it rose by 40% of pre-war consumption. [3] Three out of four land girls were employed by local farmers, the rest by the county War Agricultural Executive Committees.

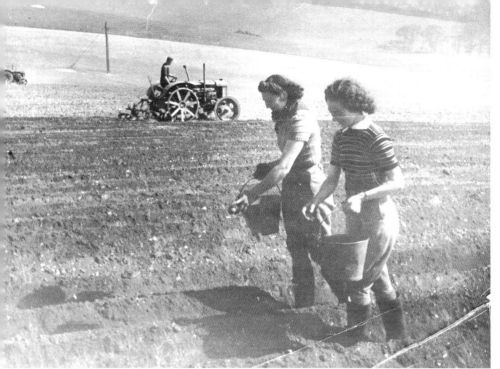

**18 Planting potatoes in Falmer, Brighton, 1942**
*This is one of a series of photographs showing agricultural work undertaken in the Brighton area as part of the war effort.*

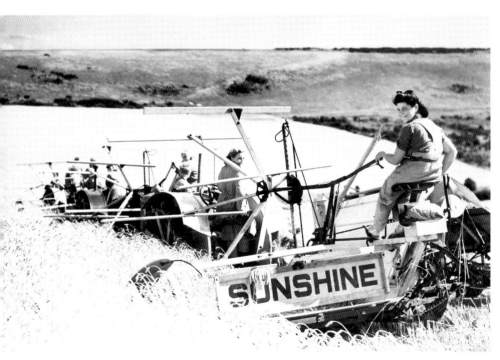

**19 Land girls working a combine harvester on the Sussex Downs, August 1941**
*The original caption for this propaganda photograph reads 'But for the present war, the greater part of the Downland would in a few years time have become an impenetrable bush and scrub...'*

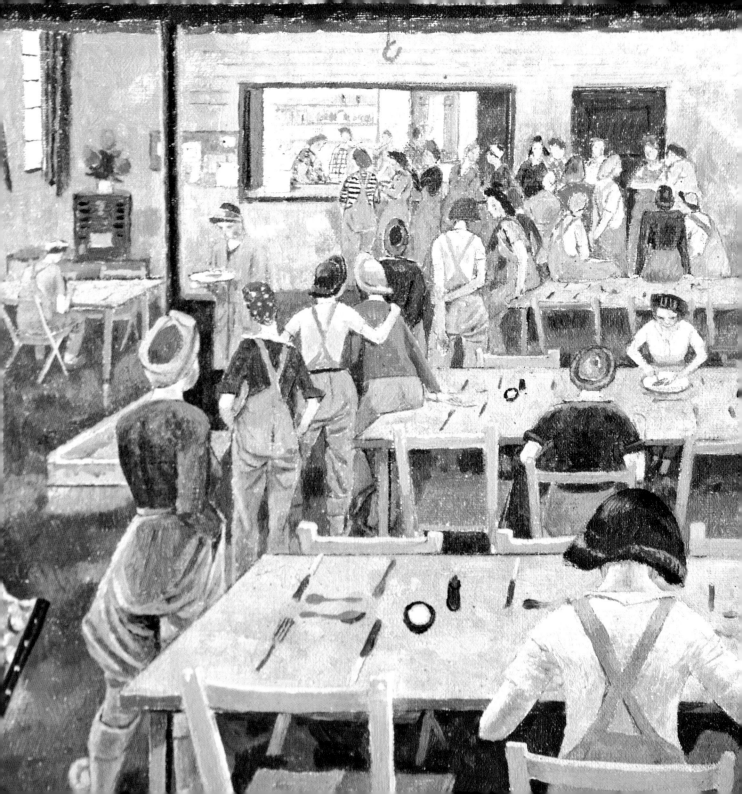

In Spring 1942 Prime Minister Winston Churchill ordered general female conscription: women could choose to enlist in the services or undertake war-related occupations, such as textiles or munitions manufacture. In 1942 the Women's Timber Corps was re-formed to provide pit props for the coal mines, telegraph poles and general timber. It was co-ordinated by the Home Timber Production Department of the Ministry of Supply (rather than the Ministry of Agriculture and Fisheries).

During World War II, Britain's farming industry became significantly more mechanised. With the implementation of the American Lend-Lease Scheme, which provided Britain with funding, it was made possible to invest in technology: in 1939 there were 55,000 tractors in Britain, but by 1944 this had increased to 175,000.[5] (One tractor could plough three to four times as much land as a team of horses.). In 1936 combine harvesters that were suited to European conditions became available (they were already in widespread use in America and Australia). In 1939 there were 50 working on British farms, and by 1941 there were around 1,000.[6] In *Land at War*, a book published anonymously by the Ministry of Information in 1944 (but known to be written by Laurie Lee), it was observed 'To townsmen who regard the harvest as a picturesque rural festival, the combine harvester is a blot on the landscape. To farmers, who have to make a living out of the landscape, it is the loveliest thing a man can have in his field.' In 1943 there was a bumper harvest and the number of land girls reached a peak at some 80,000, 2,124 of whom were working in East Sussex and 1,586 in West Sussex.[8]

The daily work of the land girl could be repetitive and monotonous; it could also be hazardous or even deadly. This is well documented in the daily diary written by Gwenda Morgan, who was born in Petworth, Sussex, in 1908. Her first day on the land was in August 1939, just before war was declared. She noted 'Felt tired and rather blistery, but think I shall like it very much.'[9] Day after day she undertook 'poultry and dungweeding'. In her entry for 26 August 1940, she wrote 'Air activity overhead during afternoon. When I'm working out in the fields there is absolutely nowhere to run for shelter (it's the most open farm I've ever seen), and I don't at all like being out (usually all alone) with machine-gun fire overhead. If a German plane comes low over me I shall try to hide in the turnips.'[10] M Bettles recalls the intense heat, and feeling the earth tremble when there were doodle-bug raids. 'One of our Land Army ladies was killed in Hastings on a Sunday dinner time, the sirens had gone and she must've been out somewhere and she was killed.'

Most land girls moved away from home and lived in WLA hostels or billets. In 1942 there were 375 hostels already open or in course of preparation in England and Wales; by 1944 this number had almost doubled to 668, nine of which were in East Sussex (there had only been three in September 1941) and seven in West Sussex. The land girls were charged a minimum of £1 a week for board and lodging in a hostel.

**20 Evelyn Dunbar, 'Women's Land Army Hostel', 1943**
Oil on canvas 22.5 x 22.5cm
*Evelyn Dunbar was appointed an official war artist in Spring 1940. Honouring her remit to record the war 'in all its aspects', she depicted the land girls undertaking dairy training with artificial udders in a cowshed; sorting potatoes on the land; and carrying out their daily domestic routines in their hostel (queuing for a meal, preparing for bed). Dunbar was a good seamstress, and her rendition of the rear view of the land girls in their baggy-seated breeches is carefully observed.*

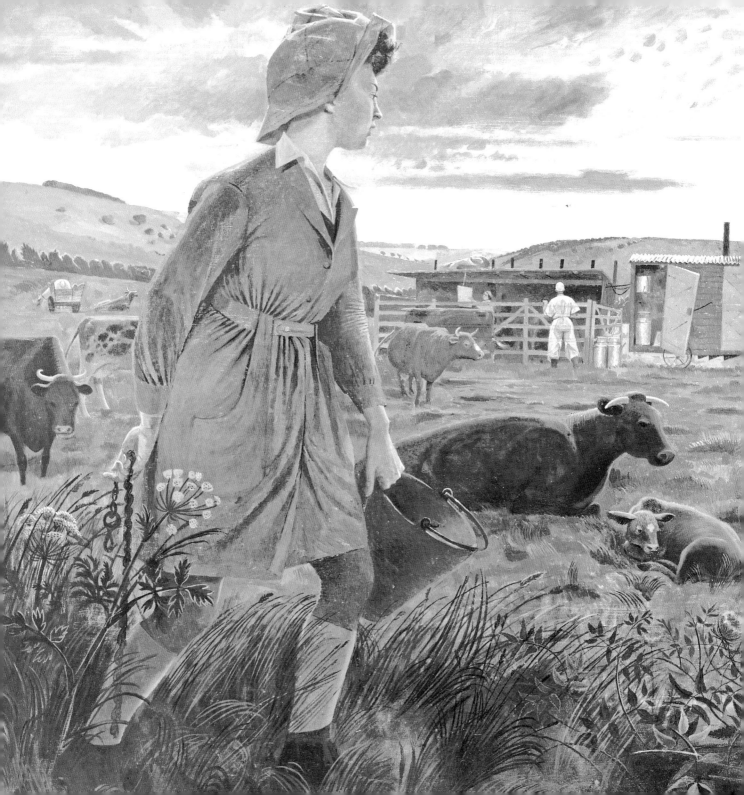

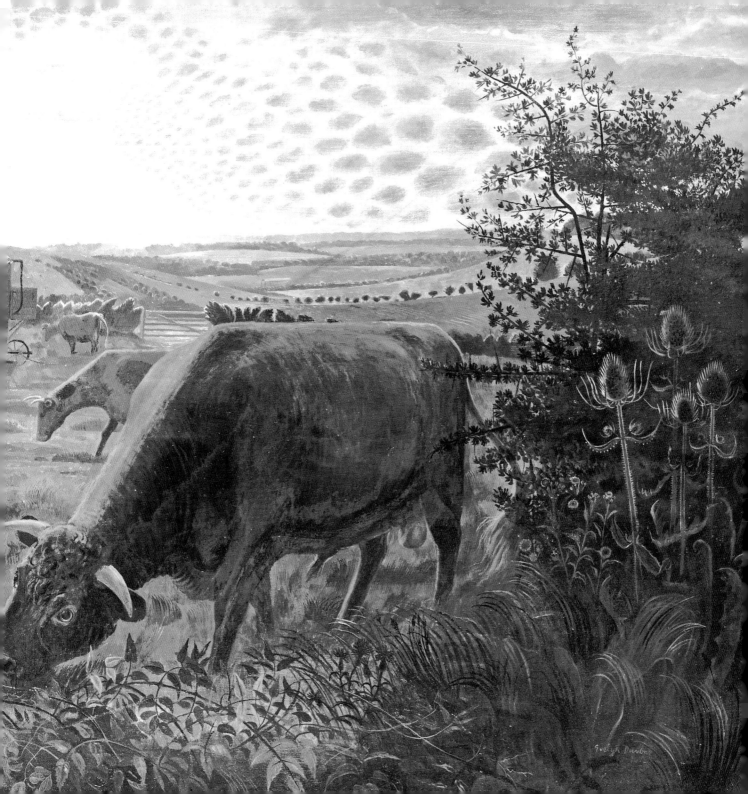

Dorothy Medhurst stayed in a hostel in Peacehaven and then lived in billets, some of which were better than others: 'Well, the thing is that the farmers wanted the land girls and so they just imposed them onto the farm workers. The farm workers then … were in tied cottages, they didn't argue with the boss over anything, they just had to accept what happened.' The land girls had to give their ration books to the landlady, who provided their food. County representatives were appointed to oversee the 'moral and social welfare' of the land girls. The woman who came to see M Bettles was '…Posh! She used to come over in her high heels and her car and she'd say "Afternoon girls! Everything all right? Good. Bye Bye!" And she'd go!'

The handbook *LAND GIRL: a Manual for Volunteers in the Women's Land Army* (1939) was written by Dr W E Shewell-Cooper (a prominent organic gardener and prolific writer). In a chapter entitled 'Making the most of the country', new recruits from the towns were offered tips about how best to fit in with country life and communities. 'The volunteer will soon find that, as the other girls from the village do not use make-up, she will prefer not to use it herself, so as not to look conspicuous. She will find, too, that she will get such a healthy colour to her cheeks that rouging will not be necessary.' [11] Documentation dated 1944 states that the Government issued beauty products and cosmetics to the value of 1s per land girl per month. ('Tattoo' lipstick cost 4s. 5d, and a refill 2s. 6d; a small liquid make-up by Miners cost 10s. 5d. Ponds face creams were also available.) [12]

The land girls' leisure-time was brief: they were allowed one half-day off a week, and not necessarily on a Saturday; were entitled to three days' holiday with pay after working six months continuously with the same employer, and after a further six months' employment were allocated two more days. The hostels had common rooms where the women could relax and, as in the previous war, various diversions such as competitions and knitting clubs were organised. Local WLA clubs were formed in many towns (one of the first was in Worthing, West Sussex, which opened in 1941), and in 1944 the Land Army Club (at Chesham Street, London SW1, where the headquarters was moved the same year) was opened as a gift from the British War Relief Society of America. For many, the social highpoint was going to a dance or 'village hop', which servicemen stationed nearby also attended.

Romances sometimes blossomed into marriage. Peggy Sayers states 'I always felt a sense of pride and satisfaction at doing my bit for the war and of course the special legacy really, was that for the past 60 years, I've been happily married to the son of the family with whom I was billeted. So that really was the best thing.' In June 1944 *The Land Girl* announced that the WLA (along with the Women's Auxiliary and Nursing Services) had received a gift of ten wedding dresses from women's clubs in America. Land girls who were getting married could apply to borrow a dress. By August 1946, *The Land Girl* advised that the loans had to cease 'owing to the life of the dresses coming to an end!'

By 1945, British agriculture was in much better shape than at the outset of war (see the national and local statistics cited in the Appendix). It was thus with great dismay and indignation that the WLA were advised by the Government that the land girls were not entitled to the gratuities offered to women working in state-employed services. After making vociferous objections that fell on deaf ears, Lady Denman resigned in protest. To supplement the work of the existing agricultural community, the services of the WLA were to prove so essential that it was not disbanded until November 1950. A post-war recruitment leaflet (c1946) appealed for another 30,000 women to join the WLA: 'The war is over but in our fields and on our farms the Battle for Food goes on.'

**22 'They learn to be Lumberjills', 1943**
*Land girls, some dressed in uniform and others in mufti, dance with British soldiers to the music of a band at a large hall near their camp in Culford.*

1.  Elliston, R.A., *Lewes at War* 1939–1945, S.B. Publications, Sussex, 1995: 161

2.  Briggs, Asa, *'Go to It!'*, Imperial War Museum/Mitchell Beazley, London, 2000: 59

3.  Ministry of Information, *Land at War*, H.M.S.O., 1944: 63

4.  Briggs, Asa: 52

5.  *Land at War*: 23

6.  '1943 is a Panzer Harvest', *Picture Post*, 29 August 1943: 22

7.  *Land at War*: 32

8.  *The Land Girl*, December 1943: 16

9.  Morgan, Gwenda. 2002. *The Diary of a Land Girl 1939-1945*, The Whittington Press, Herefordshire: 1

10. :44

11. :96

12. Letter dated 12.5.1944 from Ministry of Agriculture and Fisheries announcing allocation. Cosmetics issued by the Board of Trade. Burrell Archive.

Quotes: Eileen Jones, Dorothy Medhurst, Peggy Sayers, M Bettles, extracts from Royal Pavilion and Museums, Brighton and Hove Oral History Collection 2009.

**23 'She married her boss – Romance of Sussex land girl and farmer'**
*Land girl Miss Gladys Dunning married Mr E Stevens of Yew Tree Farm, Chalvington, Sussex. As the couple left Chalvington Church the land girls formed a guard of honour, holding a variety of raised farming tools to form a bridal archway. .*

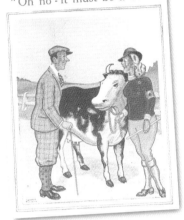

"But taking a Cow to a Bull is hardly a job for a girl, surely the farmer could do it himself. "Oh no - it must be a bull."

**24 Cartoon postcard by Jonar, 1940s**

*An exaggeratedly curvaceous land girl is depicted wearing a racy, tight, red – rather than the bottle-green – sweater, and demonstrating faux naïveté about animal reproduction. The land girls might have replaced male labour, but the men were fighting for the country and gender hierarchies continued*

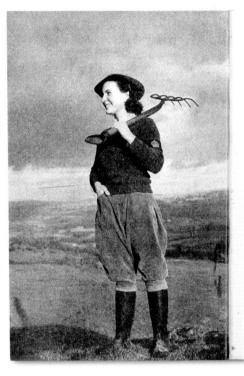

THE WOMEN'S LAND ARMY

★

V. SACKVILLE-WEST

MICHAEL JOSEPH LTD.
26 Bloomsbury Street, London, W.C.1

**25 `The Women's Land Army' (1944), by Vita Sackville-West**

*This book was written as an official history of the WLA. Vita Sackville-West was a member of the WLA Kent County Committee. The book was dedicated to Her Majesty the Queen, who was the patron of the WLA. All royalties were donated to the WLA Benevolent Fund, which aimed to support land girls with medical costs and fund retraining.*

# Uniform

In a letter dated 11 September 1939, Lady Denman advised the Ministry of Supply that 'With the exception of about 400 pairs of gumboots, there is at present no uniform at all, nor is there any indication of any further supplies being received in the near future.' Of the 1,000 volunteers undergoing training, 600 had been issued with dungarees, gumboots and an overcoat; the remaining women had only their own clothes. She also pointed out that 'Whereas some local girls can probably manage without uniform the average girls from the industrial towns have nothing at all to wear suitable for farm work.'

By December, however, uniform supplies were generally available. Each volunteer was ideally allocated a uniform comprising twelve or more items that were (whenever possible) manufactured in Britain, from materials that included cotton, wool, leather, rubber and metal. An itemised list of uniform and illustrations of how they should be worn was printed in *LAND GIRL: a Manual for Volunteers in the Women's Land Army*.

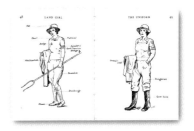

26 **Illustrations of WLA uniform published in** *LAND GIRL: a Manual for Volunteers in the Women's Land Army*, **by W E Shewell-Cooper**

A serviceable rainproof mackintosh
A khaki overall coat
Two fawn shirts with turn-down collar
A pair of corduroy breeches
A pair of dungarees
A green knitted pullover
Three pairs of fawn stockings
A pair of heavy brown shoes
A pair of rubber gumboots
A brown felt hat
A green armlet with red royal crown on it
A badge of the 'buttonhole' type

It does not list the heavy wool greatcoat that was also issued. From May 1942 the allocation was increased by three pairs of stockings, a shirt and an overall coat. If required, special sizes could be ordered. Uniform was made to rigorous standards, to ensure a responsible use of material and labour resources (this is especially evident in the 'make' of the breeches and greatcoat). Additional items could be purchased: a brown leather belt (3s. 3d), a WLA tie (1s. 9d), and a pair of pull-on trousers (8s).

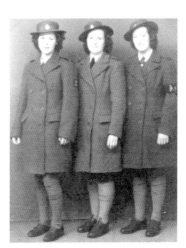

27 **A group of three land girls wearing 'correct' formal (as opposed to working) uniform**

-2-

**TABLE OF UNIFORM ORDERS FOR 1943 PLACED WITH THE MINISTRY OF SUPPLY AND ADMIRALTY.**

| Item of Uniform | Ordered for delivery between 1st Jan. & 31st March, 1943. (Orders placed 19.5.42. and 31.7.42.) | Ordered for delivery starting 1st April, 1943. (Order placed 29.9.42.) Sept | Ordered for delivery starting 1st July, 1943. (Order placed 10.12.42) | Total |
|---|---|---|---|---|
| Greatcoats | 14,000 | 40,000 | 26,500 | 80,500 |
| Oilskins & Mackintoshes | 85,000 | 40,000 | 25,000 | 150,000 |
| Hats | 80,000 | 45,000 | 25,000 | 150,000 |
| Breeches | 105,000 | 85,000 | 60,000 | 250,000 |
| Pullovers | 85,000 | 40,000 | 25,000 | 150,000 |
| Shirts | 150,000 | 130,000 | 60,000 | 340,000 |
| Overall Coats | 150,000 | 70,000 | 50,000 | 270,000 |
| Dungarees | 140,000 | 70,000 | 60,000 | 270,000 |
| Stockings | 444,000 | 270,000 | 222,000 | 936,000 |
| Shoes | 85,000 | 90,000 | 25,000 | 200,000 |
| Boots | 115,000 | 95,000 | 10,000 | 220,000 |
| Gumboots | 15,000 | (Orders placed quarterly accordingly to quantity of raw rubber allocated by Rubber Control) | | |
| Leggings | 70,000 | 45,000 | 10,000 | 125,000 |
| Badges | 35,000 | - | 50,000 | 85,000 |
| Armlets | 35,000 1st year | 20,000 1st year | 20,000 1st year | 75,000 |
|  | 12,000 2nd " | 15,000 2nd " | 20,000 2nd " | 47,000 |
| Good Service Badges. | 80,000 | 150,000 | 30,000 | 260,000 |

**28 Women's Land Army uniform orders and supplies, 1943**

The brown and green 'natural' palette of the WLA uniform suggests that it was intended – like tweed – to 'tone' with the rural environment. Whilst its coloration might have passed without comment, the garment styling in conservative rural communities did not always blend in.

Lady Denman's surviving paperwork reveals that the organisation and administration involved in placing uniform orders (and chasing them), as well as the storing, distributing, replacing and repairing of uniform, was hugely time-consuming and often exasperating. There were frequent shortages, partly because uniforms for the Armed Forces required many of the same materials and processes of manufacture, and their needs were paramount. In 1942 the introduction of a complex system of coupon collection and surrender entailed another swathe of administrative processing. The WLA's Uniform Officer was a K Doman; she regularly wrote articles on appropriate wear and care in *The Land Girl*. The East Sussex County Office and uniform store was based at 166 High Street, Lewes; the Uniform Officer and Magazine Secretary for the county was Miss Audrey Strange.

Lady Denman and her staff were also preoccupied with non-uniform issues: the land girls were not provided with any 'walking out' clothes, nor were they supplied with underclothes. (The Women's Royal Naval Service, the WRENS, were provided with two pairs of black woollen knickers, and the Auxiliary Territorial Service, the ATS, with two brassières and four pairs of knickers).[1]

Lady Denman's valiant battle to ensure the land girls were properly clothed, not only for practical reasons but also for morale, was often met with antipathy from the Ministry of Agriculture and Fisheries and the Ministry of Supply. When she suggested that headquarters staff and county officials might also be uniformed, her proposal was not only dismissed, but she was also curtly informed that 'The Women's Land Army is not an army; it is not a disciplined force; it does not have officers and ranks. It is not even an adjunct to any uniformed service, but to the main body of men and women engaged in food production, i.e., the farmers and farm workers. The uniform issued to its working members is working kit primarily and merely happens to a secondary degree to be uniform.'[2] However, for the land girls, and in broader culture, both contemporaneously and today, this uniform – and it was undoubtedly regarded as uniform – is inextricably entwined with their seminal wartime contributions.

By drawing on oral testimony from surviving land girls, autobiographies, contemporaneous publications and archival documentation, it is possible to derive evocative and wide-ranging insights into wartime circumstances, war work and lives lived.

### WLA hat

Brown felt with grosgrain ribbon trim, worn with WLA badge

'Yes, I liked them – quite a number of girls didn't, but they were quite good fun. They were like cowboy hats.' *Dorothy Medhurst*
Dorothy worked as part of a gang in the Peacehaven area and undertook general farming work in Lewes.

'We didn't wear the hat, only if we were going out in the uniform.' Pat Jobsey, one of a gang of market gardeners who worked in the Brighton area.

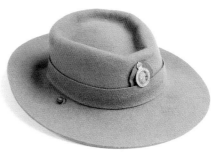

**29 WLA Hat**

The hat was made especially for the WLA – it was not based on standard army designs – which meant that there were generally fewer problems with supply. However, in November 1939, initial orders were delayed when the trimmers who sewed on the ribbons went on strike for higher pay.[3]

### WLA tin helmet

Tin helmets, manufactured in four sizes, were provided on request to land girls working in areas where there was an airborne threat. Many local land girls experienced raids. Una Wilson remembers driving her tractor up Bear Road, a steep hill in Brighton in 1941, before trees were planted: 'You could see right out to the Palace Pier, I just saw these planes coming and I could see the bombs dropping from them … I thought, "My God, I'm going to get out of there!" and I got down by the cemetery wall and thought "They won't have far to take me!"'

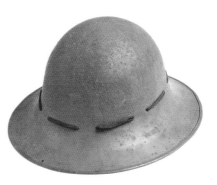

**30 WLA tin helmet**

### WLA mackintosh

Treated cotton, size small
As a result of rubber shortages from 1942 the WLA was obliged to accept light oilskins instead of this type of heavy mackintosh (detail overleaf).

### WLA blouse

White cellular-weave cotton
Manufacturer: Cotella, size large, 1943
These blouses were intended for everyday work. They were manufactured with short (seen overleaf) as well as long sleeves. In 1942 the WLA required production of about 12,650 a week, but supplies were delayed in favour of the army's needs. As they were always scarce, were made from lightweight fabric and were worn next to the skin, few survive today.

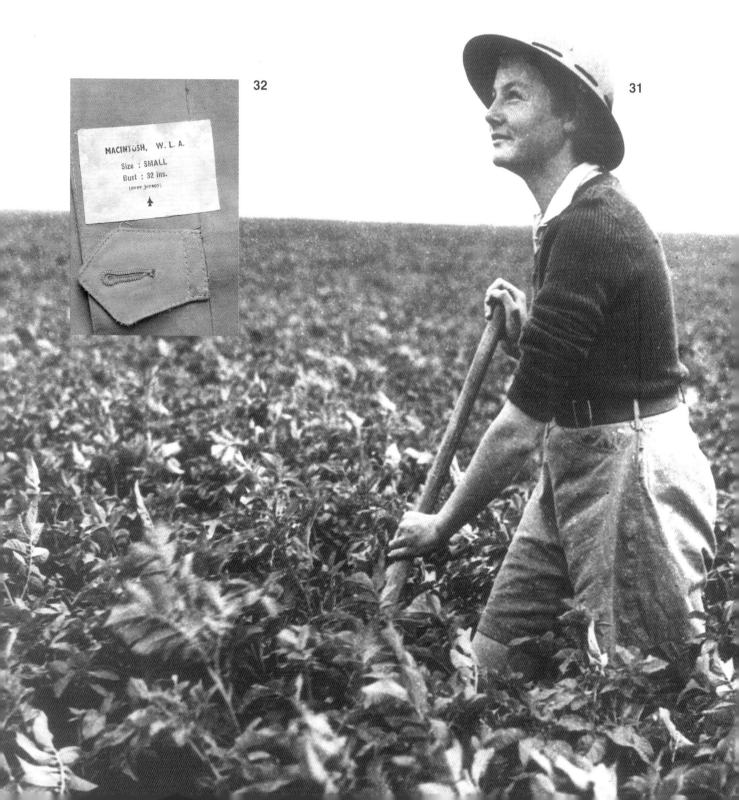

31

32

MACINTOSH, W. L. A.

Size : SMALL

Bust : 32 ins.

(over jersey)

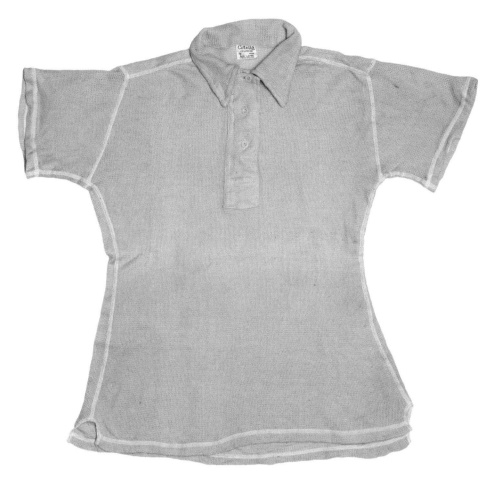

**33 WLA blouse**

**31 Land girl in Sussex wearing a protective tin hat**

*'Down on doodle-bug farm, right in the southern England's front line, the land girls have to wear tin hats all day while fighter planes and A.A. guns shoot down the flying bombs all around them. The harvesting must go on so this pretty land girl protects her head from shrapnels and bravely goes on working in the fields.'* Original official caption.

**32 WLA mackintosh (detail)**

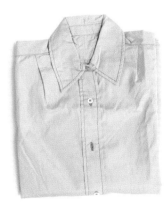

**34 Shirt**

## Shirt

Fawn-coloured cotton
Worn by Miss Helena L Reeves
Standard war-issue, long-sleeved cotton shirts were offered as alternatives to the cellular-weave blouses. This shirt belonged to Miss Helena Louisa Reeves, who was born in Hastings and worked as a land girl between February 1941 and February 1946. In 2008, aged 91 years, she received the Government's badge of honour.

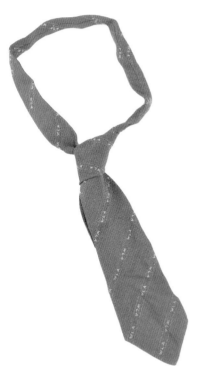

**35 WLA tie**

**36 Helena Reeves in her WLA uniform**

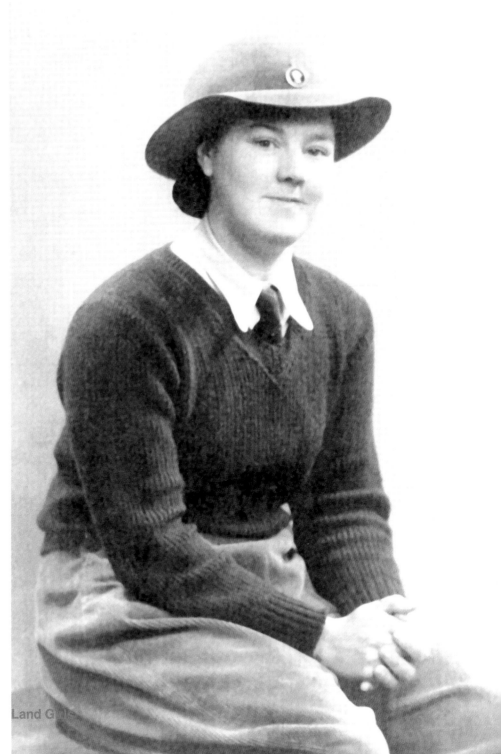

## WLA tie

Rayon with woven diagonally striped 'WLA' design
Manufacturer: Tootal Broadhurst Lee Co.
Worn by Helena L Reeves

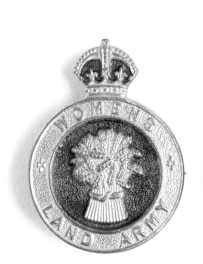 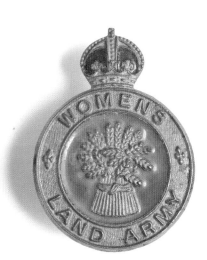 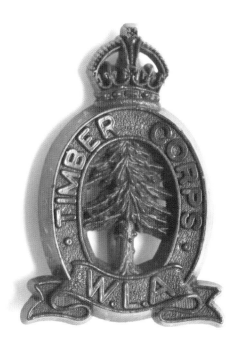

## WLA badges

Badges, featuring the crown and a corn sheaf, were issued to land girls, committee and official organisers, and district representatives.

As the war progressed, metal shortages became more acute. When, in 1942, the Ministry of Supply proposed that the WLA should receive cloth badges, Lady Denman protested that the metal badges (and armlets) were the only 'prestige items' of uniform issued to the WLA and were essential for morale. The WLA continued to be issued with metal badges, but they were made from stamped, wafer-thin metal, as pictured here.

In December 1943, the WLA's Uniform Officer sent a memo to all county representatives to notify them that 'All second-hand badges in stock should be returned to Balcombe at regular intervals for regilding and repair, no matter how small the quantity may be.'

**37 WLA badges**
*(left) Enamelled badge manufactured in 1942 by Messrs H.W. Miller, Birmingham*
*(centre) Painted, stamped metal, post-1942 (without manufacturer's mark)*
*(right) Timber Corps badge*

**Timber Corps badge**
Bakelite
Manufactured by A A Stanley & Sons, Walsall
The Timber Corps wore the same uniform as the land girls, apart from a green beret and their badge, which features a pine tree with the words 'Timber' and 'Corps' either side, and 'WLA' across the bottom.

'Please Chief Officer, hear this earnest plea;
Give us ties and shoulder tabs marked W.T.C.
For when I'm wearing uniform and stepping out with joy,
All the local yokels whistle "Here's the Farmer's Boy,"
And while I'm not denying that agriculture's fine,
I'm proud to be identified with spruce and larch and pine.'
(first lines from the poem 'On Uniform', by 'Lumber-jill' R. Randle)[5]

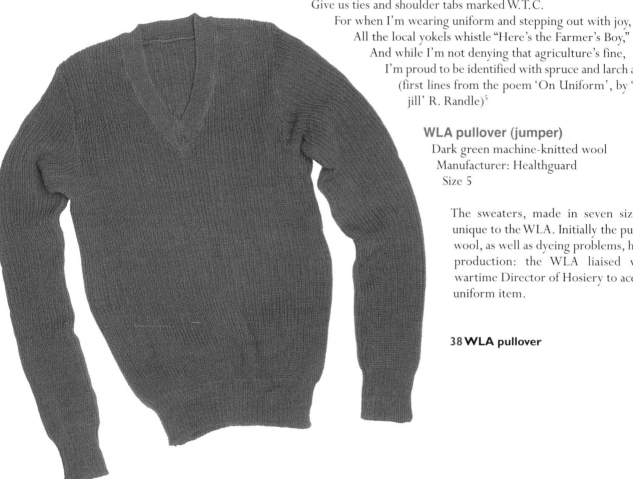

**WLA pullover (jumper)**
Dark green machine-knitted wool
Manufacturer: Healthguard
Size 5

The sweaters, made in seven sizes, were unique to the WLA. Initially the purchase of wool, as well as dyeing problems, hampered production: the WLA liaised with the wartime Director of Hosiery to acquire this uniform item.

**38 WLA pullover**

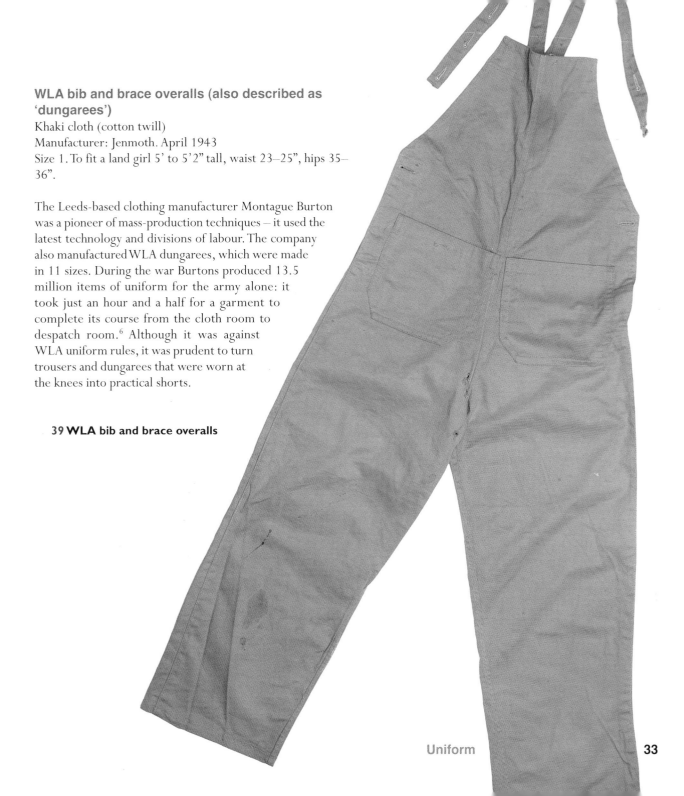

## WLA bib and brace overalls (also described as 'dungarees')

Khaki cloth (cotton twill)
Manufacturer: Jenmoth. April 1943
Size 1. To fit a land girl 5' to 5'2" tall, waist 23–25", hips 35–36".

The Leeds-based clothing manufacturer Montague Burton was a pioneer of mass-production techniques – it used the latest technology and divisions of labour. The company also manufactured WLA dungarees, which were made in 11 sizes. During the war Burtons produced 13.5 million items of uniform for the army alone: it took just an hour and a half for a garment to complete its course from the cloth room to despatch room.[6] Although it was against WLA uniform rules, it was prudent to turn trousers and dungarees that were worn at the knees into practical shorts.

**39 WLA bib and brace overalls**

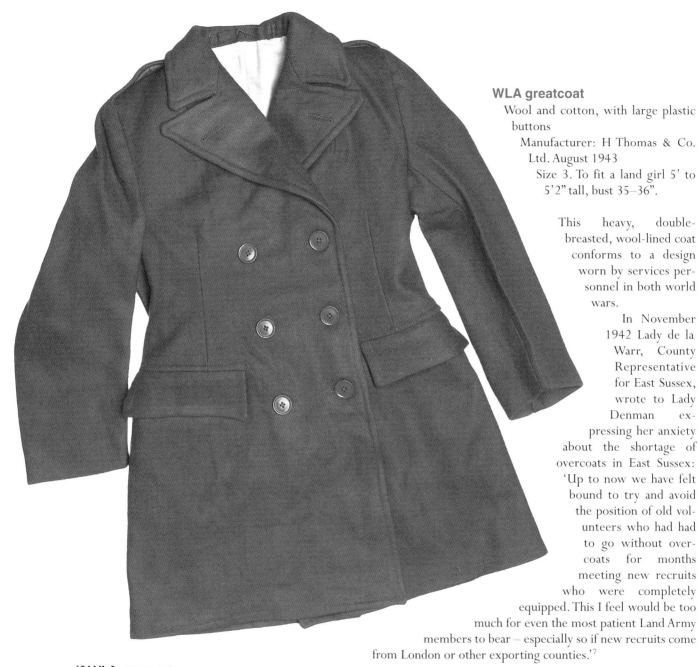

## WLA greatcoat

Wool and cotton, with large plastic buttons

Manufacturer: H Thomas & Co. Ltd. August 1943

Size 3. To fit a land girl 5' to 5'2" tall, bust 35–36".

This heavy, double-breasted, wool-lined coat conforms to a design worn by services personnel in both world wars.

In November 1942 Lady de la Warr, County Representative for East Sussex, wrote to Lady Denman expressing her anxiety about the shortage of overcoats in East Sussex: 'Up to now we have felt bound to try and avoid the position of old volunteers who had had to go without overcoats for months meeting new recruits who were completely equipped. This I feel would be too much for even the most patient Land Army members to bear – especially so if new recruits come from London or other exporting counties.'[7]

40 **WLA greatcoat**

## WLA Good Service Armlets
Felted wool armlets with applied awards
Manufacturer: Messrs Fryer, Battersea

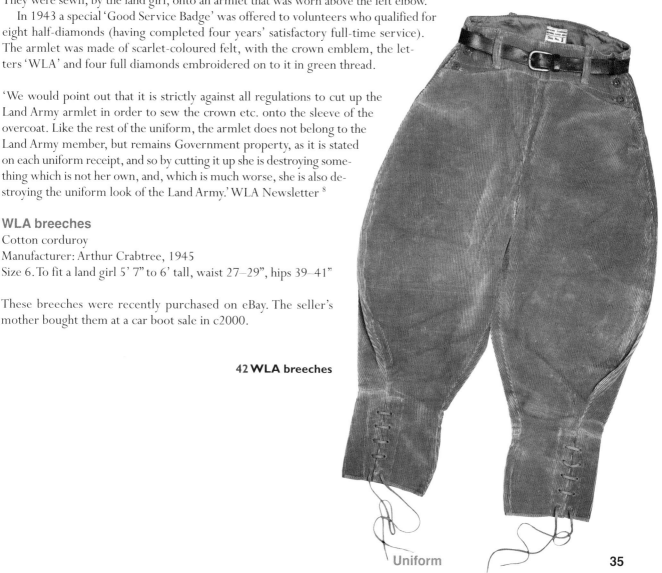

**41 WLA Good Service Armlet**

A red felt half-diamond, outlined in green, was awarded to a volunteer who had completed six months' satisfactory service; another was awarded for the completion of a year. They were sewn, by the land girl, onto an armlet that was worn above the left elbow.

In 1943 a special 'Good Service Badge' was offered to volunteers who qualified for eight half-diamonds (having completed four years' satisfactory full-time service). The armlet was made of scarlet-coloured felt, with the crown emblem, the letters 'WLA' and four full diamonds embroidered on to it in green thread.

'We would point out that it is strictly against all regulations to cut up the Land Army armlet in order to sew the crown etc. onto the sleeve of the overcoat. Like the rest of the uniform, the armlet does not belong to the Land Army member, but remains Government property, as it is stated on each uniform receipt, and so by cutting it up she is destroying something which is not her own, and, which is much worse, she is also destroying the uniform look of the Land Army.' WLA Newsletter [8]

## WLA breeches
Cotton corduroy
Manufacturer: Arthur Crabtree, 1945
Size 6. To fit a land girl 5' 7" to 6' tall, waist 27–29", hips 39–41"

These breeches were recently purchased on eBay. The seller's mother bought them at a car boot sale in c2000.

**42 WLA breeches**

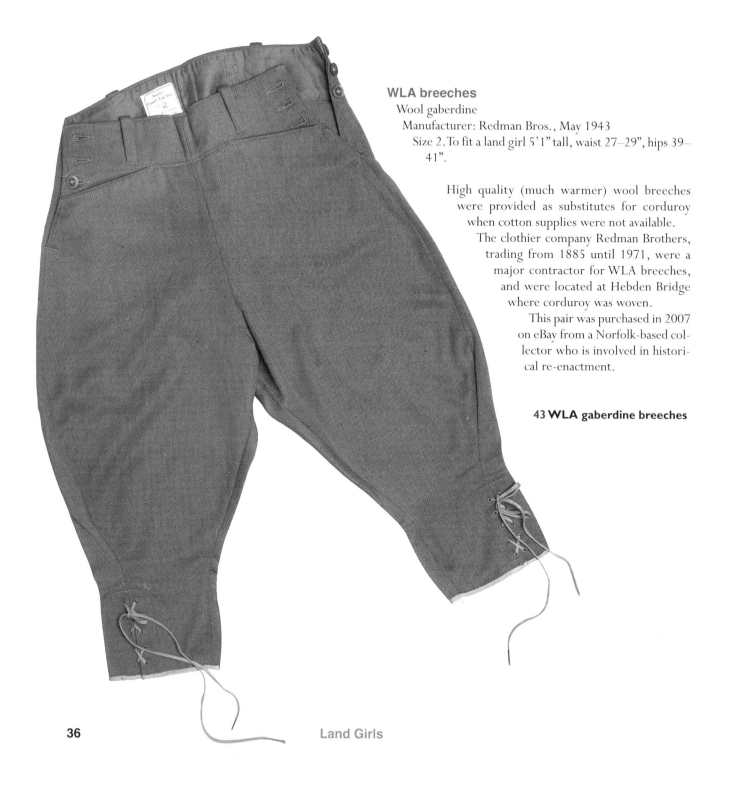

**WLA breeches**
Wool gaberdine
Manufacturer: Redman Bros., May 1943
Size 2. To fit a land girl 5'1" tall, waist 27–29", hips 39–41".

High quality (much warmer) wool breeches were provided as substitutes for corduroy when cotton supplies were not available.

The clothier company Redman Brothers, trading from 1885 until 1971, were a major contractor for WLA breeches, and were located at Hebden Bridge where corduroy was woven.

This pair was purchased in 2007 on eBay from a Norfolk-based collector who is involved in historical re-enactment.

**43 WLA gaberdine breeches**

## WLA overall coat (also known as a 'milking coat')

Khaki cotton twill
Manufacturer: A. Learner & Son. November 1942
Size No: 1: To fit a land girl 5'–5'2" tall, bust 32"

In order to permit maximum movement the WLA coats were shorter than many overalls issued to women workers. The front-fastening buttons are raised by nickel shanks, which are attached to the garment reverse via nickel loops. Standard army issue, they are popularly known as 'bachelor buttons', as they do not require a needle and thread to attach.

This garment was sold on eBay by a Brighton-based vintage clothing dealer who advertised it as 'Superb for a collector or re-enactor or simply just to wear. A classic piece of work wear history.'

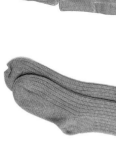

**44 WLA overall coat**

## WLA belt

Brown leather
These could be purchased from WLA headquarters for 3s.

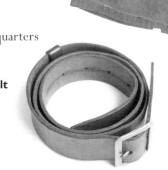

**45 WLA belt**

## WLA stockings (long socks)

Wool
No maker's mark.

Throughout the war there were shortages of good quality wool. Army socks were made on the same machines as stockings, and as the army's needs were prioritised, stockings were scarce. These have clearly never been worn.

**46 WLA stockings**

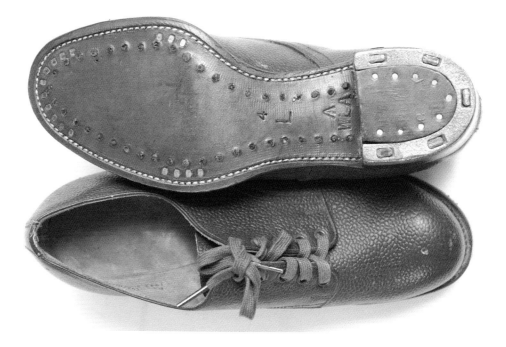

### WLA shoes
Brown-grained leather uppers and soles, metal heel irons and toe plates, and low stacked heels
Size 4

Norah Turner remembers 'The heavy walking shoes issued to us were ideal for our work, and they were very comfortable to wear. They had just one drawback, and that only became obvious when we walked on concrete paving in the streets, or farmyards, especially if it happened to be frosty. The shoes were made from sturdy leather and, to add extra strength and lengthen their lives, a metal horse-shoe stud had been built into the heels. Walking along a roadway or pavement, we sounded like a stampede of cavalry proportions and other pedestrians, hearing our approach from behind, were amazed upon looking around, to see that there were only the four of us.' [9]

All shoes were made on lasts officially approved by the Chief Inspector of Shoes. At the beginning of the war, only black leather was available. This pair was issued to Miss Helena L Reeves, who clearly never wore them.

## Gumboots
Black rubber
Size 5 1943

By January 1940, pre-war stocks of gumboots had been distributed and new production was dedicated to the fighting forces. The Treasury granted special permission for the WLA to import 9,000 pairs from Canada. Henceforth, quarterly orders for gumboots were placed according to the quantity of raw rubber allocated by the Government's Rubber Control Unit.

In January 1942 there were no gumboots in stock: of an order placed for 60,000 pairs, just 13,185 pairs had been received by March. Following the Japanese invasion of Malaya and Burma in December 1941, rubber supplies were cut off and all contracts were cancelled. *The Land Girl* published advice on how to ensure longevity from these precious items, and damaged boots were returned to WLA headquarters who forwarded them for repair to the Dunlop Rubber Company in Manchester.

When the war ended in 1945, after much negotiation and as part of the Government's drive to retain and recruit land girls, it was agreed that each member would receive the ordinary civilian clothing ration, the 'industrial ten' (an additional allowance for those undertaking heavy work), and a special allowance of 26 coupons upon entry to obtain suitable underwear, the uniform, and subsequent replacements.[10]

When they ceased service, the land girls were mandated to return most items of their uniform, which was government property. They could retain the greatcoat if the shoulder flashes were removed or exchange their coat for another that had been dyed navy blue. At various times it was permissible for other items, such as the hat, to be kept. It was intended that serviceable items would be sold on to working land girls. However, the reality was that most issued garments were completely worn out.

In return for the uniform, land girls were given up to 12 coupons provided that they had not had their full quota of uniform replacements during the previous year. In an internal memo Mr Ord Johnstone, from the Board of Trade, confessed to having '…rather a guilty conscience' about the land girls' predicament.

'After two or three years in the Land Army doing strenuous outdoor work and lifting, the girls, who generally come from town life, do undoubtedly grow considerably, particularly those who joined up in their teens, and many of them find the civilian clothes they had before they went into the Land Army just won't meet round them. This means that on the very small refund they get they must practically refit themselves with civilian clothing, which is manifestly impossible.'[11]

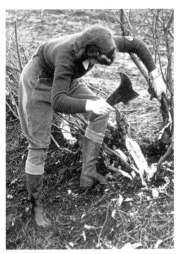

**48 Gumboots**
*Official photograph of a land girl wearing gum boots whilst hedging.*

A great many land girls had been literally reshaped by their wartime labour.

Just after the war, Norah Turner wrote that she was allowed to keep one shirt, one pair of shoes and a greatcoat dyed navy blue: 'The authorities are evidently determined that the poor land girl shall be a Cinderella to the end.' [12] Eileen Jones, who worked in gangs in the Brighton area and for a market gardener in Woodingdean, was also irked about having to return her uniform, and the land girl's generally poor deal:
'Churchill and what reckoned that we didn't warrant it because we were civilians. How can you be civilians when you are in uniform?'

The uniform, however, was not important to Eileen Strong, who undertook general farm and dairy work in Sussex. When she was asked about what happened to her uniform, she said 'I really don't remember. You see, it didn't enter your head that it mattered. The war was over and, you know, you didn't want it anymore - so you just didn't think about how you got rid of it.' Joan Snelling, a land girl who published her wartime memoir in 2004, had the benefit of hindsight when she recorded 'We had to hand in our uniforms, which I grudged, especially my well-worn leather boots. So I have nothing to show for my five years' work, except a couple of badges, good muscles and splendid health.' [13]

1.  *Fall in for War Service for Women: A Complete Guide*, Government publication, c.1939: 8 and 16
2.  Letter dated 15 May 1941, Burrell Archive
3.  Letter written by Lady Denman, November 28 1939. Burrell Archive
4.  Memo to Non-Ferrous Metal Control, Ministry of Supply 11.6.1942
5.  Ministry of Supply,(n.d, c1945) Meet the Members: A Record of the Timber Corps of the Women's Land Army Bennet Brothers, Bristol: 68
6.  Ronald Redmayne, *Ideals in Industry*, 1955: 155–7
7.  Burrell Archive
8.  WLA West Sussex County Committee Newsletter No 8: February 1944. Weald & Downland Museum
9.  Norah Turner, *In Baggy Brown Breeches and a Cowboy Hat*, 1992: 45–46
10. Statement from the Ministry of Supply, titled 'Women's Land Army', PRO, dated 4 June 1945
11. Mr Ord Johnstone, PRO, report dated 18 May 1944
12. Norah Turner: 156
13. Joan Snelling, *A Land Girl's War*, Old Pond Publishing, Ipswich, 2004: 92

Quotes: Dorothy Medhurst, Pat Jobsey, Una Wilson, Eileen Jones, Eileen Strong, extracts from Royal Pavilion and Museums, Brighton and Hove Oral History Collection 2009.

# Uniformity

**'Uniform must be uniform or it loses all its point. Come out as gay or as shabby or as Bohemian as you like in civilian clothes, but don't try to express your personality in your uniform.'**
'Uniformity', *The Land Girl*, April 1942

Have you seen the Land Girl
With her uniform complete,
And seen how very smart she looks
So workmanlike and neat.

Or else the one whose overcoat
Is worn o'er any dress
Land Army socks and high-heeled shoes,
T'is funny none the less?

And people turn and look again
"My dear what can she be
D'you think she's dressed up for a joke
From a funny comedy?"

So smartly wear your uniform,
Be proud that you can be
A member of that worthy force,
The Women's Land Army.

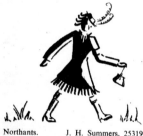

Northants.          J. H. Summers, 25319

An excellent way to procure large quantities of much needed darning wool is to cut off the worn out feet of discarded Land Army stockings and unravel the remains.

Herts.          M. L. Holder, 7482.

**49 'Have you seen the Land Girl' poem by Northamptonshire land girl J H Summers, published in *The Land Girl*, December 1947**

In a leaflet distributed to newly recruited land girls, a section on uniform makes explicit that 'The uniform of the Land Army is the property of the State. Therefore it is a contravention of regulations to cut up, mutilate, dye or alter in any way any item of uniform issued to its members.'[1] It was expected that when uniform was worn it would be worn respectfully.

There was no obligation to wear uniform for daily work – indeed, certain items were not always available; nor were they always suitable for the job in hand or the weather. The land girls were necessarily resourceful, and this was usually commended: a photograph of Barbara Greenshields (née Jupp) working at Sindles Farm, Westbourne, West Sussex, shows her wearing gaiters made from her worn-out gumboots with the sole cut off, over her leather boots.[2] Other items were also adapted. Dorothy Medhurst states that 'We had to cut off some old dungarees that went at the knees, we cut them off to make shorts out of them and just improvised like that.'

In place of the hats, which many land girls reserved for 'best', they often wore headscarves, which were more practical and personal. In her memoir *Petticoats to Pitchforks* (published in 2004), former land girl Terry Finamore recalled 'Pat was ironing a piece of cloth which she had dyed bright red to wear as a turban to cover her hair the next day. This was a triangle, usually bought from the chemist as an arm sling, most of us used these as it was more economical than buying scarves.'[3]

Una Wilson recalls the women she worked with in Brighton wearing snoods.

'Usually on a Friday you would find us with turbans – or on a Saturday morning rather, because we worked to lunchtime. We finished at half past twelve ....so we'd come with turbans so we didn't muck up our hair for the weekend.'

Pat Jobsey recalls that for especially hot days 'We used to make sun-tops out of headscarves…'

It was when the land girls were seen in public that they were expected to wear either full uniform or their own clothes. *The Land Girl*, 1942 front-page article 'Uniformity' reported that '…a volunteer seen in the streets of a large town (this is a true story) wearing a hat cocked on one side and tied on with red ribbon in a large bow under her chin,

**50 'Land Army Fashion Page, A rally of L.A. hats', drawn by Somerset land girl E B Wells, *The Land Girl*, August 1944**

*The way the WLA hat was worn and adapted by the land girls was the subject of more consternation to officials than any other item of uniform.*

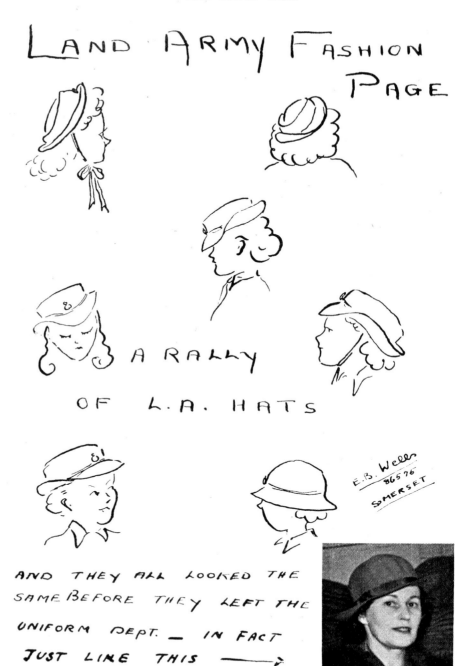

The photograph is of Mrs. R. S. Hudson wearing a Land Army Hat—taken when she visited the Uniform Store at Balcombe.

red tie and fancy shoes with otherwise correct uniform makes passers-by gaze at her with a wild surmise as to whether it is she or the Land Army which has gone crackers.'

Several of the land girls interviewed for this project reported that they only wore their hats for formal uniformed events. Dorothy Medhurst, formerly a milliner, describes how they should have worn '…the hats straight on our heads, you know, very properly- but we didn't. We used to sew bootlaces onto the hats and tie them onto our chins and wear them on the back of our heads like cowboys. Much frowned upon if any of the officials saw us.'

Such practices were not confined to the land army, or indeed the women's services. Brian Davies served in the army during the early 1950s: his duties included the supply and administration of uniforms. He reports that although some sergeant majors were over-zealous in their checks, 'Even so Service Dress Hats were "slashed" i.e. the standard issue peak was cut and pushed up into the brow of the hat to extend the rounded peak to a resting position on the bridge of the wearer's nose. The standard issue black and/or Blue/Green or Grey Beret was also savaged by plunging it into alternately boiling and then cold water, the purpose of which was to shrink said beret to give a more "natty-looking" head dress.'

In November 1944 the West Sussex Land Girls Council met in Chichester. Uniform was the last item on the agenda and the minutes note that '…there was such a bombardment of questions on this sore subject that it was impossible to deal with them all.' However, it was agreed that under no circumstances should uniform be combined with 'civvies' – to which the County Chairman enquired 'who was going to enforce this and how?'[5]

1. Burrell Archive

2. Powell and Westacott: 88

3. Finnamore, Terry, *Petticoats to Pitchforks*, Edward Gaskell, Devon, 2004: 49

4. Sackville-West, 1944: 24-25

5. Report from meeting of West Sussex Land Girls Council at the Council Chamber, County Hall, Chichester, 25 November, 1944: 6

Quotes: Dorothy Medhurst, Pat Jobsey, Una Wilson, extracts from Royal Pavilion and Museums, Brighton and Hove Oral History Collection 2009.

**51 'Is this the way to Oldham please? Why – don't yer wear braces missy?' Bamforth comic series no. 683. Postmarked January 1919**

*The land girls, often depicted conversing with an elderly non-uniformed farmer, were parodied for wearing what was considered overtly masculine clothing whilst displaying stereotypically feminine responses to country life. Here, Bamforth also highlights the problems associated with ill-fitting uniform.*

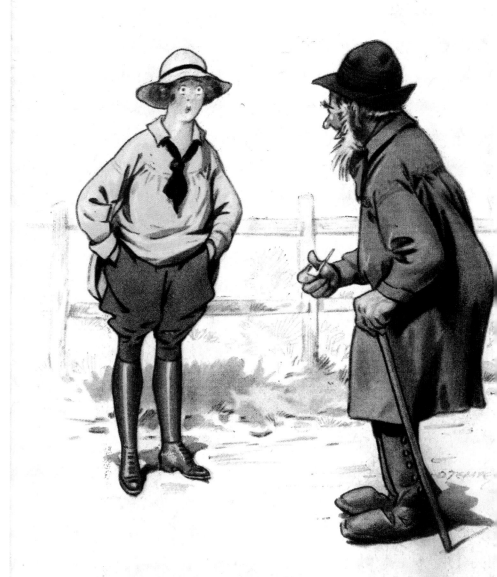

Is this the way to Oldham, please ?
Why—don't yer wear braces, missy ?

# A Biography of Breeches

'I emerged from the interview already mentally clothed in the coveted khaki breeches…' Norah Turner, *In Baggy Brown Breeches and a Cowboy Hat: 8*

**WOMEN'S LAND ARMY UNIFORM SUPPLIES, 1942.**

Employed Strength of the Women's Land Army on January 1st, 1942 was 21,736.

Anticipated Employed Strength of the Women's Land Army on December 31st, 1942 was 55,000

| Item. | Stock in hand Jan. 1st 1942. | Expected deliveries on contracts due from Jan.1st to March 31st. | Actual quantities received deliveries on from Jan. 1st to March 31st. | Expected deliveries on contracts due from April 1st to June 30th. | Actual quantities received deliveries on from April 1st to June 30th. | Expected deliveries on contracts due from July 1st to Sept. 30th. | Actual quantities received deliveries on from July 1st to Sept.30th. | Expected deliveries on contracts due from Oct 1st to Dec. 31st | Actual quantities received deliveries from Oct 1st to Dec. 5th | Total deliveries expected Jan. 1st to Dec. 31st, 1942 | Quantities actually received Jan. 1st to Dec. 5th, 1942. |
|---|---|---|---|---|---|---|---|---|---|---|---|
| Greatcoats | 12,000 | 1,800 | 3,000 | 11,966 | 7,000 | 9,799 | | 47,500 | 20,270 | 69,500 | 43,835 |
| Oilskins & Mackintoshes | 3,891 | 30,000 | 31,820 | 5,000 | 3,620 | 15,000 | 14,420 | 48,912 | 19,583 | 98,912 | 69,443 |
| Hats | 11,174 | 24,000 | 35,977 | 11,000 | | 4,000 | 10,346 | 21,000 | 14,006 | 60,000 | 60,329 |
| Breeches | 14,397 | 48,000 | 6,460 | 2,000 | 34,778 | 22,000 | 24,119 | 33,000 | 32,076 | 105,000 | 97,433 |
| Pullovers | 6,916 | 24,000 | 20,206 | 11,000 | 14,014 | 5,000 | 18,530 | 20,000 | 17,892 | 60,000 | 70,642 |
| Shirts | 18,775 | 60,000 | | 15,000 | 56,354 / 41,900 | 20,000 | 57,913 / 36,014 | 75,000 | 50,290 | 170,000 | 164,447 |
| Overall Coats | 16,757 | 65,000 | | | 56,715 | 10,000 | 8,465 | 35,000 | 8,839 | 110,000 | 74,019 |
| Dungarees | 23,623 | 70,000 | | | 33,873 | 10,000 | 75,122 | 35,000 | 7,294 | 135,000 | 135,013 |
| Stockings | 36,188 | 104,000 | 53,700 | 26,000 | 99,086 | 25,000 | 28,550 | 121,000 | 101,796 | 276,000 | 283,132 |
| Shoes | 13,135 | 36,000 | 23,674 | 4,000 | 23,709 | | 14,542 | 15,000 | 21,307 | 65,000 | 83,232 |
| Boots | 7,439 | 6,000 | 3,162 | 9,000 | 4,946 | 21,000 | 29,955 | 41,500 | 31,856 | 77,500 | 69,919 |
| Gumboots | 60,000 | 13,185 | | | | | | | | | |
| Leggings | | | | | | 40,000 | 38,915 | 10,000 | 16,244 | 50,000 | 57,159 |
| Badges | | | | | | | | | | | |
| Armlets | 20,000 | 14,573 | | | 5,497 | 8,000 | | 12,000 | 13,044 | 40,000 | 35,114 |
| Good Service Badges. | 52,000 | 33,950 | | | 5,864 | 864 | | | | | |

## 52 WLA Uniform Supplies, 31 December 1942

*Over the course of 1942, the year women were conscripted, the number of land girls more than doubled from 21,736 to 55,000. Of these, 1,032 were employed in East Sussex and 1,216 in West Sussex: between June and November that year 1,652 and 1,340 pairs of breeches were issued respectively, from a total of 31,125 pairs made.*

For many people, the personal and public perception of the land girls, during both world wars, was – and remains today – inextricably entwined with their uniformed bodies and, in particular, the breeches they wore. This chapter explores the lifecycle of WLA breeches, both those that were completely worn out and those that are in pristine condition and in circulation today.

Whilst the land girls were travelling around the country and working on and digging into the land, the raw material (generally cotton) for the breeches they wore had been grown and picked overseas (in some instances by American land girls); shipped to UK ports; transported by goods trains to textiles factories where it was spun, dyed and woven into cloth, then taken on to clothing manufacturers who made, packed and sent

the made-up breeches, again by goods train, to Balcombe Place, Sussex. There, they were sorted, stored and either transported to a uniform centre, or posted to the recruit as new or replacement uniform. The breeches were then worn, by one or more land girl, until they had no wear remaining. However, some breeches were never issued. Today, still unworn, quantities of these are in circulation, offered for sale by militaria and vintage clothing dealers, at car boot fairs and in virtual markets.

## Ordering uniform

In the Burrell Archive, there is copious typewritten correspondence from Lady Denman to officials at the Board of Trade and the Ministry of Supply stressing the urgency and importance of clothing the land girls in suitable uniform. There are also numerous internal papers, with handwritten and typed lists of uniform orders placed, received and pending.

Orders had to be placed six months in advance and the WLA HQ had to guesstimate the number and sizes of future recruits, as well the quantities of replacement garments required. Since about 200,000 women joined the land army during its eleven-year span this was a considerable undertaking.

## Raw material

WLA breeches were usually made from cotton, which is not grown in the UK. During the late 1930s, with war on the horizon, the Government strategically accumulated imported raw materials, including uniform cloths. Cotton was crucial, not only for civilian clothing and uniform but also for making tyre cases, belting and webbing, waterproof covers, tentage, balloon covers and other equipment for the services. Although Britain had large reserves, additional orders were placed to secure the cotton crops from the British West Indies, Gash and Kassala. In addition, rubber reserves were exchanged for American cotton. But, as supplies were built, losses were suffered: heavy bombing on the Port of Liverpool in the winter of 1940 led to 28,000 tons of stored cotton being destroyed. In 1941 additional supplies were purchased from Peru. In spite of these endeavours, there were still shortages of cotton throughout the war.

## Woven cloth

Bales of cotton were transported by ship and goods trains to UK textile factories, where they were spun into yarn, dyed and woven. (The manufacture of iron, used to build ships; cotton textiles and the railroads were the three elements that had formed the nucleus of Britain's industrial revolution.) Just four months into war, on 17 January 1940, Lady Denman recorded in her 'Notes with regard to Supplies': 'Initial difficulty of obtaining Bedford cord due to the fact that the makers of this material were full up with army contracts. Eventually a supply of corduroy was found.'

| Totals ordered from Ministry of Supply. | Details of Contracts placed. | Quantity allocated for contractor. | Date Contract due to begin. | Date Contract due to finish. | Rate per week. | DELIVERIES. | | | | | | | | | | | | | | | | | |
|---|---|---|---|---|---|---|---|---|---|---|---|---|---|---|---|---|---|---|---|---|---|---|---|
| | | | | | | Sept 12th | Sept 14th | Sept 26th | Oct 3rd | Oct 12th | Oct 17th | Oct 14th | Oct 31st | Nov 7th | Nov 14th | Nov 21st | Nov 28th | Dec 5th | Dec 12th | Dec 19th | Dec/Jan 26th | Jan 2nd | Jan 16th |
| | C. W. Crowther. | 2,250 | 1.9.42. | 2.11.42. | 250 | – | | | – | – | 241 | – | | – | 120 | 120 | · | 232 | – | – | 157 | 160 | 200 |
| | John Lord | 2,250 | 4.9.42. | 4.11.42 approx. | 250 | 125 | 125(6) | – | 750 | 125 | 250 | 325 | 250 | 120 | 125 | Complete | | | | | | | |
| | Thos. Sutcliffe. | 1,500 | 1 week from receipt of materials. | | 250 | – | – | – | – | – | – | – | – | 400 | 100 | 400 | 231 | – | – | 340 | 29 complete | Complete receipt of materials special goo | |
| 2,090 | Redman. | 7,500 | 11.9.42. | 6.11.42. approx. | 1000 | | | 1505 | 800 | – | 1,500 | 1,100 | – | 398 | – | 162 | | 85 | 100 | | | | |
| | J. B. Hoyle. | 4,500 | 10 days from receipt of materials. | | 500 | | | | | 400 | 200 400 | | | 1500 | – | 100 | 100 | 200 | 566 | 200 | 371 | | |
| | W. Sutcliffe. | 1,500 | 1 week from receipt of materials. | | 250 | | | | | | | | | – | | | | | | | | | |
| | E. Greenwood | 300 | | | | | | | | | | | 252 Complete | | | | | | | | | | |

Corduroy is a durable cut-pile fabric, usually made of cotton, with woven, raised, parallel ribs. (The word was originally used to describe a road made of logs laid down crosswise – a corduroy road.) Hebden Bridge in Yorkshire was the centre for corduroy manufacture (the industry fell into decline in the 1960s), whilst Bedford cord, which is a similar weave but of sturdier construction, was mainly made, as the name suggests, in Bedford.

When cotton was unavailable, WLA breeches were manufactured from good quality, dull green wool gaberdine or whipcord (usually cotton or worsted in a twill weave that has a tight corded appearance). In a letter to G R Rice at the Ministry of Supply dated 12 May 1942, Lady Denman wrote 'We were glad to agree to have some of our breeches made up in whipcord but although the material is of good quality, the colour is particularly ugly and will necessarily I fear detract a good deal from the appearance of the Land Army uniform.'[1]

Once woven, the cloth was sent by goods trains to clothing factories, many of which were located in Manchester and Leeds.

## Garment manufacture

Once uniform orders were secured, Lady Denman liaised with Mr Oliver, the Deputy Director General of Clothing, whose officer, Mr Greenhalgh, who was based in Leeds, supervised WLA contracts. The labels on surviving breeches identify them as WLA and specify size, manufacturer and date of manufacture. The quality of the breeches varies, but mostly they were made to a very high specification.

On 29 February 1940 the *News Chronicle* printed a feature called 'Girls who are Clothing the Troops Sing as they Work'. It reported that a soldier's battledress passed through no less than 40 pairs of women's hands in three hours before being issued to them. Thirty-year-old Marie had worked at John Barren in Leeds (a huge clothing factory which made WLA dungarees) since leaving school, and could make eight buttonholes a minute. She told the reporter that the shift to 'khaki work' was easy but monotonous – she missed working with colour.

**53 Contracts for breeches due for delivery December 1942**
*On 12 December 1942, Lady Denman reported that the production of breeches should be in the region of 3,650 pairs a week.*

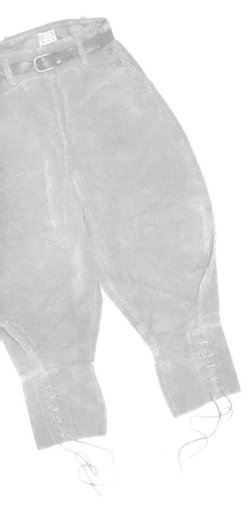

The breeches were made from cotton corduroy (four main, and ten small pattern pieces which included four belt loops), khaki cotton drill (for the pockets – this is the same material used to make WLA overall coats), dark brown cotton, khaki-coloured cotton tape and bias binding. There were six brown composition buttons, 20 brass eyelets and two green laces. Five different coloured threads were used to sew the various components: sage green, khaki, oyster, dark brown and petrol blue. A white cotton label with printed black ink specified that the breeches were made for the WLA, named the manufacturer, the date of manufacture and size (they were made in 11 graded sizes). The unit cost to the WLA was 8s.11d.

## Shortages

In a letter to Sir Cecil Weir, Director of General Equipment and Stores, Ministry of Supply, dated 3 March 1942, Lady Denman advised that by the end of February the WLA should have received 65,000 pairs of breeches but only 41,219 were delivered – making a deficit of nearly 24,000 pairs. Between January and the end of July 1943, 250,000 pairs of breeches were ordered.

## Delivery and storage

The processed orders of breeches were sent by goods train to Balcombe Place, where they were stored and sorted for distribution. Of the total staff of 35, five were employed as uniform packers.

In her official text on the WLA (1944), Vita Sackville-West describes the transformation that took place in the outbuildings – the garages, stables and squash courts – at Balcombe Place. 'These evidences of luxury have become purely utilitarian; they have been turned into warehouses. There, from floor to ceiling, are stacked the familiar green jerseys, the brown breeches, the black gum-boots, the fawn overcoats, the pale Aertex shirts. All so neat, so beautifully piled. It gives one some idea of the work involved in supplying the needs of eighty thousand girls. One is accustomed to seeing one Land-girl at a time, or perhaps a little bunch of them in a gang, but one gets some impression of the horde which, in the aggregate, the girls who "fight in the fields" really represent.' [2] Sackville-West's text evocatively uses 'empty' garments as a metaphor to visualise the vast number of women engaged within this geographically dispersed army.

In order to effectively distribute uniform to this expanding army of women, in September 1941 a new depot was opened at Higham Ferrers, Northamptonshire.

## Distribution to the land girls

Newly recruited land girls received their uniform from a local uniform depot or in the post. Dorothy Medhurst, Pat Jobsey and Eileen Jones were interviewed to become land girls in WLA premises in Lewes High Street and returned there to be fitted for their uniforms. Dorothy received her uniform in its entirety from the depot, whereas Una Wilson '…Got it in bits and bobs, you know. We'd get a pair of wellingtons and we'd get a pair of breeches and then we'd get something else… ' Uniform was central to Norah Turner's land girl identity: she describes the day she went to see Mrs Parker, the Uniform Officer at Reading. 'Having tried on five pairs of breeches, half a dozen pairs of shoes, and at least ten seemingly identical hats, I decided that I could never be the dashing young land girl that I had imagined. Somehow khaki breeches and what is vulgarly known as the bum-freezer coat do not make for glamour whichever way you look at them, least of all from behind. I was soon to discover that the uniform is designed primarily for work.'[3]

In 1941 and aged 17 years, RG Bowley went to train in dairy farming at Nash Farm in Steyning and then worked in Lyndhurst, where she was billeted with two other girls. Her uniform was posted. 'It all came in one lot to me – breeches, socks, shoes, the whole lot. It all came to the house and I tried everything … of course, I mean they did ask my size. And the shirts – I just loved the shirts, they were beautiful shirts. The material was so lovely, in fact everything about the uniform was very good. I mean it was all very well made. Beautiful! The only thing I didn't like were the shoes. They were like clodhoppers! But I soon bought myself an ordinary pair to wear out. But everything else was absolutely perfect.'

To ensure rigorous stock control, every recruit had to sign form WLA U7 on receipt of all items of uniform issued, which was then filed and stored.

## Wear, tear and care

It was intended that each land girl should be issued with two pairs of breeches, which could be replaced if absolutely necessary after 12 months, but shortages meant this was not always possible. Dorothy Medhurst states 'I had one pair of breeches last me all the war, you know, so I had to use those for going out mostly, and just used the dungarees for working unless it was very cold… '

On these bitter occasions '….Of course, I used to get wet through in these breeches. By the time the next morning came they were still wet and I'd have to put them on. It wasn't very good … I used to get chilblains on my knees because of the cold weather and the wind and the wet breeches.' She could not dry them as her landlady used to keep the coal hidden.

In a leaflet issued to new recruits, a section on uniform advised that the land girl 'See that these are an easy fit, otherwise you run the risk of tearing the fabric. NEVER make into shorts or dye any other colour.'

Norah Turner was billeted, with three other women, at a farm. After working from dawn to dusk the girls could wash their (often incredibly dirty) clothing using their toilet soap – they were permitted to use just one bucket of rainwater each – in the back yard. (None of the women had previously laundered or mended their own clothes.) Once cleaned, she describes their 'wardrobe' as an 'ingenious arrangement of nails, hammered into every clear space on the walls and door'.

Breeches were also often worn for leisure. Una Wilson went to 'village hops' at the Church Hall in Woodingdean. 'You'd go in uniform, because, well.. if you weren't in uniform people would think – "Why aren't you in uniform?" You know, you looked askance at people, young people who weren't in uniform. Mind you, the big shoes were not at all that good for dancing!' M Bettles, on the other hand, loathed her breeches. '…Horrible things, they were much too big' and never wore them except to work. 'I never wore trousers and I still don't – as soon as I got back to my billets they'd come off and I'd put on a dress or skirt.'

Breeches were not always considered appropriate wear. Lady Denman felt passionately that the land girls should not have to surrender coupons for their uniforms, for this very reason. In a letter to Mr Engholm, Ministry of Agriculture and Fisheries, dated 14 August 1941, she stressed that 'No underwear or walking out clothes are provided for volunteers and the working outfits [are] usually too muddy and stained to be used for walking, while there are many occasions on which breeches are not felt by the volunteers to be suitable wear.'[4] This was reinforced by Doris Bradley, whose father explicitly forbade her to wear her WLA uniform to church, exclaiming 'You are not going to church dressed like a man!'

Professor Elizabeth Wilson, dress and women's historian, states that 'The fact that these women went into pubs in groups on their own without men and, shockingly, that they wore breeches, gave them a reputation for immorality or even lesbianism. Their khaki breeches signified their deviant status.' (Although she never served as a working land girl, Vita Sackville-West appropriated the style of the WLA uniform in World War I. In her unpublished autobiography, she describes the 'transformative effect' she experienced when she first wore her luxurious, bespoke breeches, 'I had just got clothes like the women-on-the-land were wearing, and in the unaccustomed freedom of breeches and gaiters I went into wild spirits…'[5] She wore breeches for the rest of her life.) Elizabeth Wilson continues 'Ironically these breeches have now become iconic for some contemporary lesbians, who see in them a memory of independent women whose war work, less glamorous and less recognised than that of women in the armed forces, was just as important. The retrieval of these garments as treasured items symbolises a belated recognition of the Land Girls' role.'[6]

## Returned Breeches

When a land girl left the service she was required to return her uniform to her County Officer, who sent it on to a local, or one of the two national, uniform depots. In a memo, now housed in the collection of Portsmouth Museums and Records Service, land girls received a letter advising them to return remaining items to the Uniform Department via the branch of Marks & Spencer in Winchester High Street, with a note of their name and address enclosed. (It is possible that the WLA tapped into M&S's distribution network across the country.)

Returned breeches that were barely worn were reissued to new recruits as part of their original outfit. Worn breeches were cleaned and these were sometimes offered for sale to land girls who wanted and could afford to pay for, another pair. In 1941, a pair of worn heavy lined Bedford cord breeches (for winter wear) was sold for between 4s and 8s; unlined Bedford cord ones were priced between 7s.6d and 3s.6d, and corduroy breeches cost between 4s and 9s, depending upon their condition.[7] As the land girls had so little spare money after paying for their board and lodgings, these prices were considerable.

## Worn-out breeches

In both world wars women were employed to sift through piles of returned and deloused uniform to identify items that could be cleaned, repaired and reissued. In World War I garments that were unfit for future wear were either turned into rag or pulped to make fertiliser.[8] During the 1940s, a Women's Land Army Organisation leaflet circulated from Balcombe Place to the various county offices advised 'Where it is impossible to dispose of second-hand uniform by sale either to volunteers or to a local rag merchant, it may be disposed of free for charitable purposes.' It is satisfying to consider that the life of the land girl's breeches, like the seasons and growth of crops, might have also been cyclical: that they were ultimately of and returned to the soil.

## Survival and circulation today

It is – appropriately – customary for curators and historians to chronologically locate and interpret objects from the point of their design, make or manufacture and initial use or circulation. However, the more recent biography of historical dress can also be fascinating.

After the war vast quantities of surplus uniform, including WLA items, were sent to Europe to support various relief operations. It seems that many items were never distributed and have languished in warehouses for the last 50 or more years. Today items of WLA uniform, including the breeches, have become commercially and culturally desirable garments.

**54 WLA dolls, (left to right) Jane, Sophie, Cassie, Emily**

*During both world wars and subsequently, dolls have been made and/or dressed in replica land girl uniforms as commemorative items. In recent years, Evelyn Paine purchased these dolls because they did not look too child-like, and her sister-in-law Penny Dickson made, with infinite attention to detail and great skill, their uniforms, which replicate the styles worn in both wars.*

Land Girls

As stated earlier, WLA breeches can now be purchased from militaria and vintage clothing dealers. (As with much surviving historical dress, it is the smallest sizes that are most common.) The distinct nature (and gendered associations) of these two businesses provides insights into their contemporary appeal: one feeds into the prevailing vogue for juxtaposing and wearing new fashionable garments with historical clothes, especially items that have stylistic links with current catwalk trends (for example, Paris fashion house Balenciaga's highly profiled collection for Autumn/Winter 2007–08 featured breeches). The other serves the popular demand for authentic clothes to wear for popular wartime re-enactment events and celebrations of rural life in times past. Although replica garments are available, participants are prepared to pay significant sums in order to dress in the 'real thing'. Both of these trends form part of a broader contemporary culture of nostalgia that has had significant impact on the culture and heritage sector, including museums.

From 1939 to 1950, the land girls travelled across the country, via rail and road, to work on the land. Many of the cotton corduroy breeches they wore continue to do so, in material form and as memories across time and space.

1. Burrell Archive

2. Sackville-West: 11

3. Norah Turner: 9

4. Burrell Archive

5. Nicolson, Nigel, *Portrait of a Marriage*. Phoenix, London, 1973: 15

6. Interview with author, August 2009

7. Letter dated 29 February 1940, Burrell Archive

8. Diana Condell and J. Liddiard, *Images of Women in the First World War 1914-1918*, 1987: 78

Quotes: Una Wilson, R G Bowley, Dorothy Medhurst, M Bettles extracts from Royal Pavilion and Museums, Brighton and Hove Oral History Collection 2009.

# 21st Century Land Girls

**55 'The land girl past, present and future'**

*An illustration by Warwickshire land girl J Kaye, published in* The Land Girl, *July 1943*

The land girls' Farewell Parade was held at Buckingham Palace on 21 October 1950. Her Majesty the Queen, Patron of the WLA since 1941, emphasised in her speech that 'They could not have done more for their country than they did.'[1] Over 11 years, the WLA recruited some 200,000 land girls, 5,000 of whom chose to remain working in agriculture. Most of the women returned to homes across Britain, some married and some had families. The land girls went their separate ways, but they shared a common experience. In the final issue of *Land Army News* (published June–November 1950) Chief Administrative Officer Mrs F C Jenkins, CBE, reflected on the achievements of the WLA and concluded 'I wonder will ever two former land army members meet, discover their shared past, and still feel themselves strangers. I think not … I think past and present will quickly be bridged with just three words … Do you remember? Do you remember?'

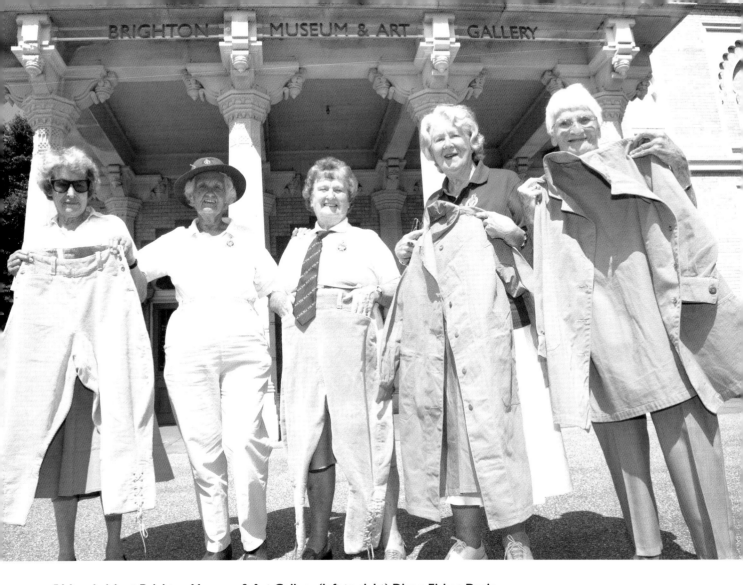

**56 Land girls at Brighton Museum & Art Gallery (left to right) Diane Fisher, Doris Bradley, Alice Racher, Beryl Gould and Nancy Johnson, June 2009**
*Memories are evoked by handling WLA uniform items that the women returned when they ceased service.*

**57 Land girl Iris Hobby, Battle of Britain Day, Newhaven Fort, 16 September 2007**

*Iris wears a combination of original uniform, a modern 'WLA' sweatshirt and her 'civvy' clothes.*

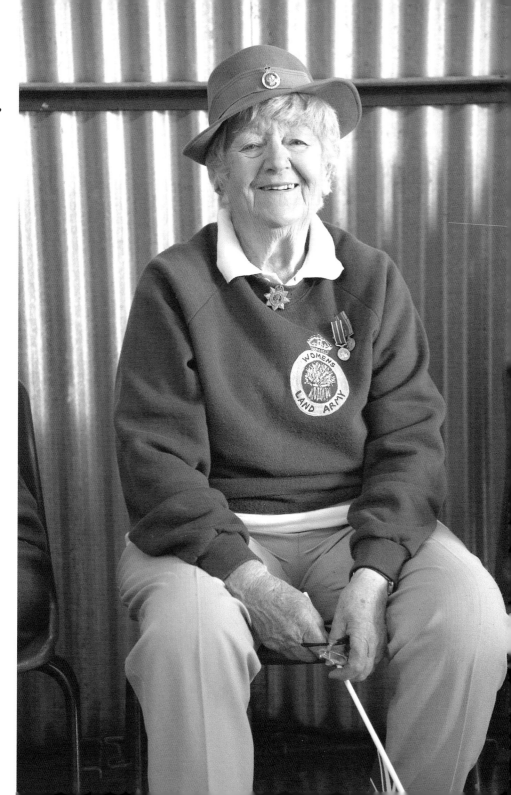

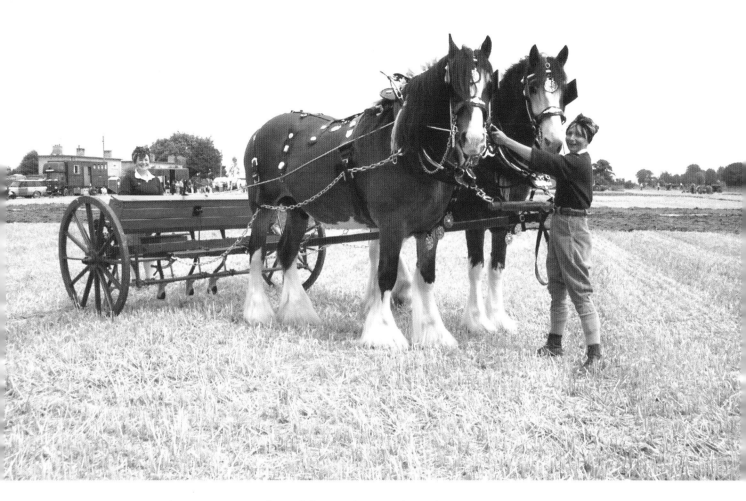

In 1964 former land girl Mrs Jean Proctor formed the British Women's Land Army Society (now disbanded) and served as its Chairman to co-ordinate national events, including rallies, a newsletter and meetings for veterans held at the Royal Albert Hall. It was not until 2000 that the land girls were allowed to join the annual remembrance ceremony at the Cenotaph. Prior to this they marched independently one week earlier. Today, in Sussex, many land girls – they still describe themselves as such – have formed networks and meet regularly for coffee. They also attend various commemorative events, such as Battle of Britain Day, staged at Newhaven Fort: here they mingle with different generations of men and women, who arrive dressed in 1940s fashions and uniform. The land girls, in contrast, wear green polo shirts or sweatshirts with painted designs of WLA badges to announce their status, combined with an assortment of badges, ties and

**58 Wendy Toomer Harlow (left) and friend, 2006**
*This snapshot was taken at the annual WLA revival day staged at Brenzett Aeronautical Museum Trust. Wendy lives on a farm with working horses and buys original WLA uniform, often on eBay, to wear for WLA revival days.*

sometimes an original hat. Since 2007 many wear with pride their new badge, issued by the government to formally recognize their determination, courage and spirit.

Uniform was, and remains, central to the land girls' experiences and identity. For some it mattered more than others. Norah Turner deeply regretted that she could not retain an item as a memento and souvenir.

'I wish I could have kept some part of it as a symbol of such a large slice out of my life, and my pride in the knowledge of a job well done. Had I been given a choice, it would have been difficult to decide, but I reckon in the end it would have had to be those baggy brown breeches and, of course, the shapeless cowboy hat.'[2]

1. *Land Army News*, November 1950: cover story
2. Norah Turner: *In Baggy Brown Breeches and a Cowboy Hat:* 123

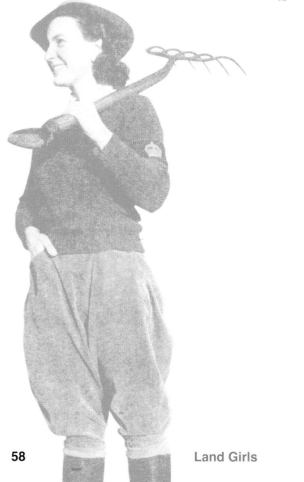

# Sources and selected bibliography

## Archives and museums consulted

The Burrell manuscripts, Knepp Castle

Ditchling Museum

East Sussex Record Office

Hastings Museum & Art Gallery

Hove Library, the Viscountess Wolseley Collection

Imperial War Museum, London

The Women's Library (London Metropolitan University)

Mass Observation Archive (University of Sussex)

Museum of English Rural Life

Newhaven Fort

Portsmouth City and D-Day Museums

Public Record Office

Royal Pavilion & Museums, Brighton & Hove

Steyning Museum

Weald and Downland Museum

Worthing Museum & Art Gallery

## Land girl oral testimonies

Part of the Royal Pavilion & Museums, Brighton & Hove Oral History Collection

M Bettles, April 2009

R G Bowley, March 2009

Pat Jobsey, April 2009

Eileen Jones, February 2009

Dorothy Medhurst, March 2009

Peggy Sayers, March 2009

Eileen Strong, March 2009

Una Wilson, March 2009

Di Winstanley, August 2009

**Sources for statistics provided by Dr Nicola Verdon**

Ministry of Agriculture and Fisheries, *Agricultural Statistics 1939-44, England and Wales, Part 1* (HMSO, London, 1947) and *Ministry of Agriculture and Fisheries, Agricultural Statistics, 1945-9, England and Wales, Part 1* (HMSO, London, 1952)

**Key texts**

Briggs, Asa. *Go To It!* Mitchell Beazley/Imperial War Museum, London, 2000

Clarke, Gill. *Evelyn Dunbar: War and Country*, Sansom and Company, Bristol, 2007

Clarke, Gill. *The Women's Land Army: A Portrait*, Sansom and Company, Bristol, 2007

Condell, Diana and Liddiard, J. *Images of Women in the First World War 1914–1918*, Routledge & Kegan Paul, London, 1987

Grayzell, Susan. 'Nostalgia, Gender and the Countryside: Placing the Land Girl in First World War Britain', *Rural History: economy, society, culture* (10.2.1999), pp. 155–170

Hall, Anne. *'Land Girl: Her story of six years in the Women's Land Army 1940–1946'*, Country Bookshelf, 1993

Hurstfield, J. *The Control of Raw Materials*, HMSO and Longmans, London, 1953

King, Peter. *Women Rule the Plot: the story of the 100 year fight to establish women's place in farm and garden*, Duckworth, London, 1999

Huxley, Gervas. *Lady Denman D.B.E. 1884–1954*. Chatto & Windus, 1961

Matless, David. *Landscape and Englishness*, Reaktion Books Ltd., London, 1998

Ministry of Information. *Land at War*, HMSO, London, 1944 (written anonymously by Laurie Lee)

Ministry of Supply. *Meet the Members: A Record of the Timber Corps of the Women's Land Army*, Bennet Brothers, Bristol, n.d., c.1945

Morgan, Gwenda. *The Diary of a Land Girl, 1939–1945*, The Whittington Press, Herefordshire, 2002

Noakes, Lucy. *War and the British: gender, memory and national identity*. I.B. Taurus & Co. Ltd., London, 1998

Oakes, Alma and Hamilton Hill, Margot. *Rural Costume*, Batsford, London, 1970

Pegram, John. *The Wolseley Heritage. The story of Viscountess Wolseley and her parents*, John Murray, London, 1939

Powell, Bob and Westacott, Nigel. *The Women's Land Army 1939–1950*, Britain in Old Photographs series, Sutton Publishing, Gloucestershire, 1997

Priestley, J.B. British *Women go to War*, Collins, London, n.d., c.1942

Sackville-West, Vita. *The Women's Land Army*, HMSO, London, 1944

Shewell-Cooper, W.E. *Land Army Manual* English Universities Press, London, 1939

Tillet, Iris. *The Cinderella Army*, Michael Joseph, London, 1988

Turner, Norah. *In Baggy Brown Breeches and a Cowboy Hat*, Marlborough Books, Kent, 1992

Twinch, Carol. *Women on the Land: their story during two world wars*. The Lutterworth Press Cambridge, 1990

Tyrer, Nicola. *They Fought in the Fields. The Women's Land Army: The Story of a Forgotten Victory*. Sinclair Stevenson, London, 1996

Woodeson, Alison. *'Going back to the land': rhetoric and reality in women's land army memories*, Oral History (Women's Lives issue), Autumn 1993, pp. 65–71

## Magazines and journals

*The Dairy Farmer*

*The Land Girl*

*The Landswoman*

*Picture Post*

*The Queen*

# Appendix

## Agricultural statistics for the UK (thousands of acres)
Prepared by Dr Nicola Verdon, University of Sussex

| Crops | 1939 | 1940 | 1941 | 1942 | 1943 | 1944 | 1945 |
|---|---|---|---|---|---|---|---|
| Wheat | 1766 | 1809 | 2265 | 2516 | 3464 | 3220 | 2274 |
| Barley | 1013 | 1339 | 1475 | 1528 | 1786 | 1973 | 2215 |
| Oats | 2427 | 3400 | 3951 | 4133 | 3680 | 3656 | 3753 |
| Potatoes | 704 | 832 | 1123 | 1304 | 1391 | 1417 | 1397 |
| Turnips and swedes | 712 | 746 | 837 | 858 | 830 | 820 | 814 |
| Mangolds | 216 | 231 | 267 | 269 | 286 | 308 | 308 |
| Sugar beet | 344 | 329 | 351 | 425 | 417 | 431 | 417 |
| Flax for fibre | 23 | 65 | 128 | 118 | 145 | 184 | 124 |
| Vegetables | 291 | 304 | 375 | 422 | 423 | 504 | 512 |
| **Livestock** | | | | | | | |
| Cattle/calves | 8872 | 9093 | 8940 | 9075 | 9259 | 9501 | 9616 |
| Sheep/lambs | 26887 | 26319 | 22257 | 21506 | 20383 | 20107 | 20150 |
| Pigs | 4394 | 4106 | 2558 | 2143 | 1829 | 1867 | 2152 |
| Poultry | 74357 | 71243 | 62059 | 57813 | 50729 | 55127 | 62136 |

## Agricultural statistics for Sussex (acres)

| | | | | | | | |
|---|---|---|---|---|---|---|---|
| **Wheat** | | | | | | | |
| East Sussex | 12,330 | 15,057 | 24,347 | 31,048 | 45,315 | 41,607 | 28,669 |
| West Sussex | 17,862 | 18,977 | 25,173 | 28,581 | 37,445 | 36,176 | 26,838 |
| **Barley** | | | | | | | |
| East Sussex | 633 | 2,362 | 4,354 | 3,523 | 5,885 | 5,785 | 6,683 |
| West Sussex | 3,509 | 6,593 | 9,852 | 9,329 | 11,696 | 13,353 | 15,290 |
| **Oats** | | | | | | | |
| East Sussex | 10,563 | 20,172 | 27,828 | 23,073 | 24,352 | 27,899 | 31,913 |
| West Sussex | 15,151 | 22,514 | 24,634 | 20,727 | 20,529 | 24,270 | 25,756 |
| **Potatoes** | | | | | | | |
| East Sussex | 1,948 | 2,924 | 3,638 | 4,183 | 4,027 | 4,262 | 4,149 |
| West Sussex | 1,917 | 2,608 | 3,287 | 5,044 | 5,576 | 5,812 | 6,034 |
| **Mangolds** | | | | | | | |
| East Sussex | 2,495 | 3,040 | 3,798 | 3,962 | 4,397 | 4,618 | 4,457 |
| West Sussex | 3,555 | 3,926 | 4,566 | 4,297 | 4,729 | 4,791 | 4,,620 |

## Agricultural statistics for Sussex (acres)

| Crops (acres) | 1939 | 1940 | 1941 | 1942 | 1943 | 1944 | 1945 |
|---|---|---|---|---|---|---|---|
| **Sugar beet** | | | | | | | |
| East Sussex | 96 | 201 | 338 | 1,020 | 767 | 617 | 574 |
| West Sussex | 2,679 | 2,599 | 3,037 | 4,165 | 3,695 | 3,890 | 4,620 |
| **Flax** | | | | | | | |
| East Sussex | 102 | 800 | 2,476 | 3,196 | 2,881 | 3,563 | 3,120 |
| West Sussex | 16 | 425 | 1,627 | 1,565 | 871 | 1,203 | 1,044 |
| **Hops** | | | | | | | |
| East Sussex | 1,669 | 1,707 | 1,726 | 1,758 | 1,793 | 1,845 | 1,900 |
| West Sussex | - | - | - | - | - | - | |
| **Orchards** | | | | | | | |
| East Sussex | 3,533 | 3,594 | 3,679 | 3,626 | 3,562 | 3,553 | 3,475 |
| West Sussex | 2,209 | 2,259 | 2,361 | 2,272 | 2,232 | 2,273 | 2,222 |
| **Vegetables** | | | | | | | |
| East Sussex | 1,236 | 1,598 | 1,886 | 2,698 | 2,882 | 4,137 | 5,152 |
| West Sussex | 2,279 | 2,345 | 2,560 | 3,079 | 3,337 | 3,698 | 4,321 |

| Livestock | | | | | | | |
|---|---|---|---|---|---|---|---|
| **Cattle/calves** | | | | | | | |
| East Sussex | 92,124 | 97,035 | 91,050 | 95,642 | 99,520 | 100,615 | 96,297 |
| West Sussex | 61,359 | 65,652 | 62,552 | 65,607 | 67,633 | 68,434 | 66,293 |
| **Sheep/lambs** | | | | | | | |
| East Sussex | 153,106 | 145,726 | 109,110 | 107,895 | 88,418 | 81,499 | 77,413 |
| West Sussex | 75,223 | 76,660 | 60,172 | 59,847 | 47,935 | 37,860 | 35,228 |
| **Pigs** | | | | | | | |
| East Sussex | 36,907 | 40,211 | 24,561 | 20,391 | 17,997 | 18,722 | 19,781 |
| West Sussex | 30,924 | 33,106 | 18,358 | 13,005 | 11,695 | 11,533 | 13,517 |
| **Poultry** | | | | | | | |
| East Sussex | 835,247 | 792,037 | 528,926 | 429,128 | 331,732 | 358,509 | 421,592 |
| West Sussex | 566,168 | 543,421 | 346,431 | 301,119 | 224,912 | 245,411 | 295,303 |
| **Horses** | | | | | | | |
| East Sussex | 7,183 | 7,178 | 6,956 | 6,722 | 6,443 | 6,155 | 5,811 |
| West Sussex | 5,499 | 5,494 | 5,319 | 4,848 | 4,664 | 4,345 | 4,053 |

# Copyright credits

| | |
|---|---|
| Frank Butler | 11 |
| Copyright reserved | 9, 10, 18, 24, 25, 26, 27, 49, 50, 51, 55 |
| Collection of Evelyn Paine | 3, 54 |
| Doug Craib | 57 |
| Crown copyright, expired | 20 |
| Wendy Toomer Harlow | 58 |
| Hastings Museum & Art Gallery | 34, 35, 36, 46, 47 |
| Imperial War Museum | front cover right (detail), 2, 4, 5, 6, 7, 8, 15, 17, 19, 22, 23, 31 |
| Private Collection | 12, 14, 28, 48, 52, 53 |
| Royal Pavilion & Museums, Brighton & Hove | front cover left, 13, 16, 29, 30, 32, 37, 41, 45, 56 |
| ©Tate, London, 2009 | 21 |
| Clive Warwick | 1, 33, 38, 39, 40, 42, 43, 44 |

# Photographic credits

| | |
|---|---|
| Doug Craib | 57 |
| Graham Franks Photography | 56 |
| Wendy Toomer Harlow | 58 |
| Imperial War Museum | 2 (Q54600), 4 (Q28618), 5 (Q30352), 6 (Q30629), 7 (Q30614), 8 (Q30622), 15 (SG8739C), 17 (D14099), 19 (HU36274), 22 (D14123), 23 (AP8544), 31 (KY11852E) |
| James Pike Photography Ltd | 3, 29, 30, 32, 34, 35, 36, 37, 45, 46, 47, 54 |
| Private Collection | 10 |
| Royal Pavilion & Museums, Brighton & Hove | 9, 12, 13, 14, 16, 18, 24, 25, 26, 27, 28, 41, 48, 49, 50, 51, 52, 53, 55 |
| Russell-Cotes Art Gallery & Museum, Bournemouth | 20 |
| Steyning Museum | 11 |
| ©Tate, London, 2009 | 21 |
| Clive Warwick | 1, 33, 38, 39, 40, 42, 43, 44 |